HIDDEN ASSETS

SCOTTISH PAINTINGS FROM THE
FLEMINGS COLLECTION

F̲LEMINGS̲

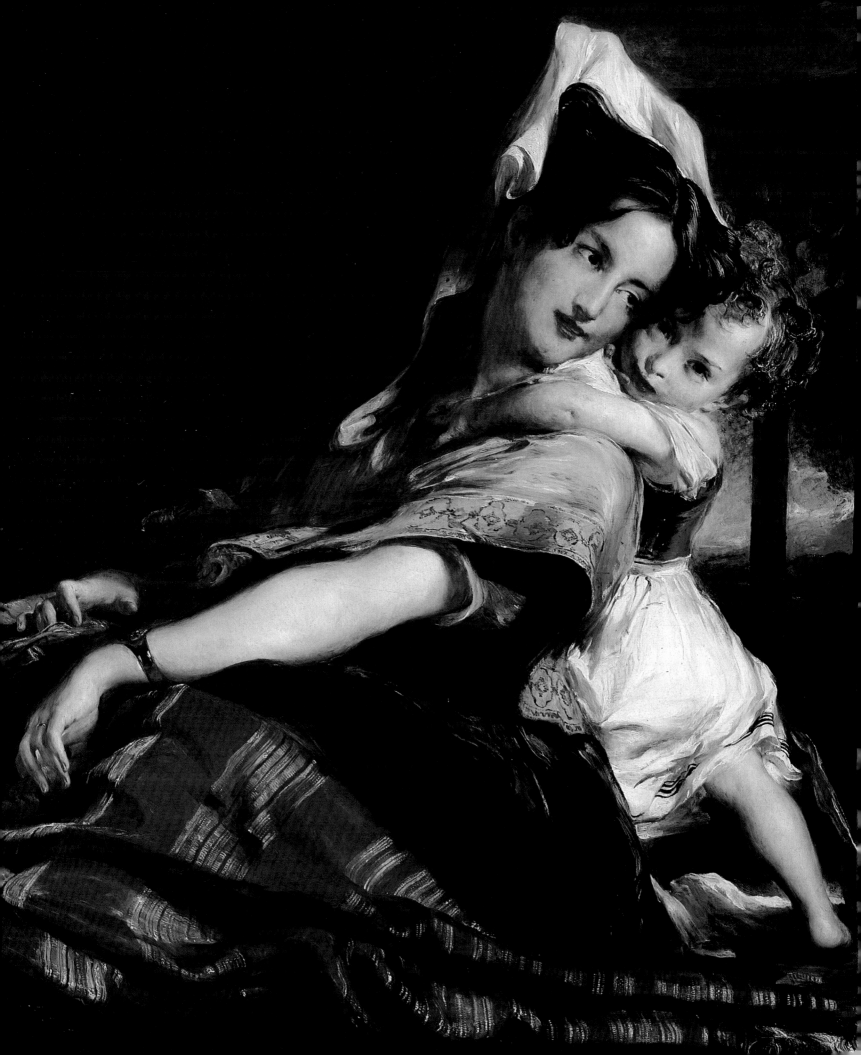

Hidden Assets

SCOTTISH PAINTINGS FROM THE FLEMINGS COLLECTION

INTRODUCTION BY BILL SMITH
CATALOGUE BY HELEN SMAILES & MUNGO CAMPBELL

NATIONAL GALLERIES OF SCOTLAND
EDINBURGH
1995

Published by the Trustees of the
National Galleries of Scotland for the exhibition
Hidden Assets: Scottish Paintings from the Flemings Collection
held at the National Gallery of Scotland, Edinburgh
3 August – 24 September 1995

© Trustees of the National Galleries of Scotland
ISBN 0 903598 57 4

Designed and typeset in Monotype Bulmer by Dalrymple
Printed in Belgium by Snoeck Ducaju & Zoon

Cover illustration: *Reclining Lady in White*
Stanley Cursiter (no.58)

Frontispiece: detail from *The Spanish Mother*
Sir David Wilkie (no.4)

Foreword

The exhibition *Hidden Assets* represents the outcome of a unique partnership between the National Gallery of Scotland and Robert Fleming Holdings, one of the City's most successful private merchant banks, whose resources include the most remarkable corporate collection of Scottish painting in Britain. Inaugurated in 1968, this collection now comprises 800 oils and watercolours by some 330 different artists of whom the majority are either native Scots or have been active for the best part of their careers in Scotland.

For the exhibition organiser, such 'hidden assets' offer an embarrassment of riches. On this occasion the Gallery has chosen sixty works which illustrate the sheer range and diversity of the Flemings collection within the period *c.*1820 to *c.*1920. Our selection includes several outstanding pictures such as *The Spanish Mother* by Sir David Wilkie and *The Unknown Corner* by James Pryde, rarities such as Copley Fielding's view of Inverary, and two of the most celebrated nineteenth-century images of West Highland emigration, *The Last of the Clan* by Thomas Faed and *Lochaber No More* by John Watson Nicol. In establishing our priorities we have also been guided by a desire to initiate a creative 'dialogue' with the National Gallery's own collections of Scottish painting through contrast and comparison. It is our hope that such privileged access to the Flemings collection will continue to stimulate constructive and challenging discussion on the representation of Scottish art in the National Galleries of Scotland.

As a celebration of a shared commitment to the promotion of Scottish art, such a collaborative venture would have been inconceivable without the exceptional degree of co-operation which the Gallery has received from Robert Fleming Holdings. The Chairman, Robin Fleming, who sanctioned Flemings' generous financial support of *Hidden Assets*, has taken an informed and close personal interest in the evolution of the exhibition from the very beginning. Our greatest debt is to Flemings curator, Bill Smith, who has not only contributed an essay to the catalogue but has shared with the Gallery's staff so many of the excitements and discoveries arising from the preparation of the exhibition. The exhibition has been selected and organised by Helen Smailes, curator of Scottish paintings and sculpture – who first conceived the idea for the project – and Mungo Campbell, curator of Scottish prints and drawings at the National Gallery of Scotland. The exhibition organisers have been ably assisted by Sally Groom and many of the staff of the National Galleries Conservation, Publishing, Information and Registrar's Departments. Without their enthusiasm and support the exhibition would not have been possible.

TIMOTHY CLIFFORD
Director, National Galleries of Scotland

MICHAEL CLARKE
Keeper, National Gallery of Scotland

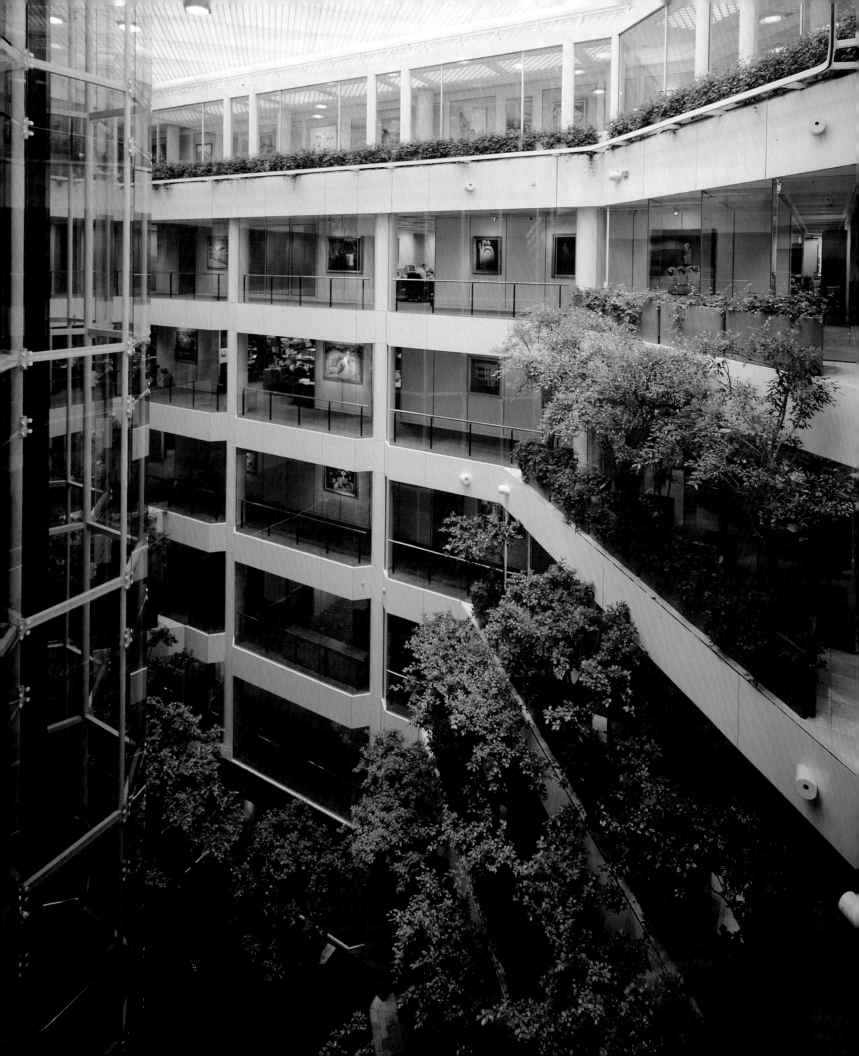

The Flemings Collection

BILL SMITH

The Flemings Collection, built up over the last twenty-seven years, comprises over 800 oils and watercolours by around 330 artists and covers the period from about 1800 to the present day. Over three-quarters of the artists represented in the collection are either Scottish born or have worked for most of their life in Scotland. About half of the total are living artists. The paintings hang throughout Flemings offices in London – not just in the directors' rooms or in the boardrooms – and in an increasing number of Flemings overseas offices.

At first sight it may appear rather surprising that arguably the finest collection of Scottish art in private hands is located not in Scotland but in the offices of a London merchant bank. However, the reason for this becomes apparent when one looks into the early history of Flemings.

ROBERT FLEMING

Robert Fleming was born in Dundee in 1845. He came from a humble background – his father was an overseer in one of Dundee's jute factories – and became one of the City of London's most shrewd and respected financiers and a very rich man. At his memorial service in the City in 1933 he was described by a noted City personality as 'Scotland's Dick Whittington'. A contemporary of J. Pierpont Morgan and Jacob Schiff, Fleming worked his way into the front rank of international financiers by sheer ability and tenacity, although he had no family connection with either The Stock Exchange or banking. Yet to his death he remained an unassuming man of simple tastes, a man of great modesty.

A bursary allowed the young Fleming to spend a year or two at Dundee High School, where he excelled at mathematics. Leaving school at thirteen, he worked in the offices of a merchant and a jute manufacturer, before becoming bookkeeper to the Dundee merchants Edward Baxter & Sons and confidential clerk to the senior partner, Edward Baxter. The latter was a very wealthy man, owning many overseas investments, particularly in America. Around 1870 Baxter sent Fleming to America to check on his investments. He returned greatly impressed with the importance of that country and the opportunities for the investment of British capital, especially in the railways, which were profiting from the ending of the Civil War and the great move westwards.

Dundee had accumulated substantial wealth from the fluctuating fortunes of the linen and jute industries. Individuals with money to invest were prepared to accept the higher risk associated with putting their money abroad in order to obtain a better rate of return than was available at home. The pound stood at a premium over the dollar of from six to eighteen per cent, so that it was an ideal time to invest money in America. For the majority of investors all that was required was a suitable investment vehicle. Fleming so impressed a group of Dundee businessmen with his ideas and enthusiasm that in 1873 it was decided to establish The Scottish American Investment Trust, the first investment trust in Scotland by a short head. The launch was so well supported that the original prospectus asking for £150,000 was withdrawn and replaced by a new one for £300,000. The same year a further £400,000 was raised,

followed by a similar amount in 1875. Fleming was appointed Secretary, although in fact he acted as the investment manager of the trusts. The funds were invested primarily in the bonds of American railway companies carefully chosen by Fleming. The early success of the trusts, which exist to this day, was largely due to Fleming's skill and indefatigable energy. He paid frequent visits to London and America to check on the trusts' investments, crossing the Atlantic no fewer than 128 times up to 1929. Good fortune attended him on more than one occasion. When in 1873 he crossed the Atlantic for the first time on behalf of the trusts, he considered travelling on the White Star steamer *Atlantic*, but decided to embark on a smaller Cunard ship. On reaching New York, he was confronted by posters announcing the wreck of the *Atlantic* off Nova Scotia with the loss of almost 600 lives.

As well as managing the trusts in Dundee, Fleming was establishing a number of important connections in London, which led to the flotation in 1888 of the Investment Trust Corporation. In 1890 he moved to London, resigning as Secretary of the Dundee trusts, although he continued for many years to act as investment adviser. He set up on his own in London in 1900 to carry on general financial business, establishing a partnership in 1909 with his elder son Valentine, who was killed in the Great War, and Walter Whigham, a young chartered accountant from Ayrshire. His younger son Philip, the father of the present chairman Robin Fleming, joined the partnership in 1911.

During his lifetime Fleming exerted an immense influence on investment and investment trusts. In a study of the investment trust movement in Britain, published in 1935, it was estimated that directly or indirectly he had a hand in the investment policies of around fifty-six investment trusts with total resources of about £114 million, a very considerable sum in the early 1930s. He was actively engaged in the business of the partnership right up until two years before his death in 1933, aged eighty-nine.

Today Robert Fleming Holdings Limited is one of the United Kingdom's most successful merchant banks. Despite its current size and worldwide coverage – it has over 6,500 staff and fifty-four offices in thirty-four countries – the bank is still a private company and the influence of the Fleming family is still very strong, providing a particularly fertile soil for a corporate art collection.

The bank's Scottish origin is an important and cherished part of its traditions. For example, over many years there has been a succession of pipe-majors on the staff. Today, in the Copthall Avenue headquarters the Flemings piper plays for five minutes or so at 9.30 three mornings a week to welcome the staff to work, even though by then the majority of them have been at their desks for an hour or possibly two. When in 1968 it was decided to purchase a few paintings to brighten up bare walls in new offices, it seemed only natural that these should be Scottish.

A COMMITTEE OF ONE

Although the family possessed a few fine pictures, the bank had no tradition of collecting paintings, unlike several of the other London merchant banks, which since their formation had built up significant collections. For Flemings it was the move to a new office on the north side of Crosby Square in the City which was to act as the catalyst.

David Donald, an Aberdonian who in 1960 had joined Flemings from Shepherd & Wedderburn in Edinburgh, suggested to his fellow directors that perhaps one or two paintings would relieve the stark bareness of the walls in the new office. The idea was enthusiastically received by his colleagues and David, a Writer to the Signet turned investment manager, who had a life-long enthusiasm for art, was asked to buy a few paintings. The only guidelines were that the paintings should be by Scottish artists or of Scottish scenes by any artist. Apart from this he was given a free hand. In 1968 business plans were a tool of the future and budgets merely vague ideas in the mind of the chairman! Certainly at the outset there was no discussion of a budget. David spent what he thought he should spend, only consulting the chairman on very few occasions, for example before buying *Lochaber No More* (no.24) by John Watson Nicol from The Fine Art Society in 1980 for what was then a relatively large sum for us. For eighteen years until his death in 1985 David acted as a committee of one, using his special blend of flair and wit to build up a fine collection of Scottish art.

Until about 1980 Scottish art was very under-rated in terms of British art. Collectors outside Scotland were

relatively few and prices reflected this. David was able to buy quality paintings by artists such as William McTaggart, E. A. Walton, S. J. Peploe and F. C. B. Cadell for sums which today seem very low. Many of these works were purchased from The Fine Art Society in London's New Bond Street, whose Scottish managing director Andrew McIntosh Patrick has been a life-long enthusiast for Scottish art. In the early years David regularly 'raided' The Fine Art Society's annual exhibitions and came away with five or six classic paintings by leading Scottish artists, which were lovingly hung on the walls at Crosby Square.

By the early 1980s, however, Scottish painting was becoming better known beyond the boundaries of Scotland. Prices increased rapidly, particularly for works by the Scottish Colourists, who were taken up by a number of London dealers. Owning a Peploe became almost a status symbol for a newer breed of collectors. In the late 1970s a good Peploe could be purchased for about £5,000. In 1988 Peploe's *Girl in White* sold at Christie's in Glasgow for £506,000, a world record for the artist. Not surprisingly, such high prices could not be sustained in the short-term and there was a sharp reaction, which was aggravated by the recent world-wide economic recession.

Thus it was lucky timing that enabled Flemings to buy well during a period when Scottish art was overlooked by many other collectors. However, it was also David Donald's keen eye for a good painting, combined with that very necessary quality in an investment manager of being able to recognise a neglected sector, that enabled Flemings by 1984 to have a superb group of paintings by the Colourists, bought from The Fine Art Society, the Lefevre Gallery in London and Aitken Dott in Edinburgh. Major purchases included Peploe's *A Vase of Pink Roses* (no.50) and *Kirkcudbright* (no.49) in 1968 and 1978 respectively, J. D. Fergusson's *Jonquils and Silver* (no.52) and *Jean Maconochie* (no.51) in 1971 and 1981, Leslie Hunter's *Lower Largo* (no.54) in 1969 and F. C. B. Cadell's *The Dunara Castle at Iona* (no.56) in 1970. It is significant that we have purchased only one Colourist oil during the last eleven years – Cadell's *The Feathered Hat* (no.55) in 1992.

Over the same period David was buying the work of painters ranging from Sir David Wilkie to the young artists of the day. In the first year alone he purchased five major

Victorian paintings – E. T. Crawford's *Edinburgh from Aberdour* (1849), Thomas Faed's *The Last of the Clan* (no.16), *The Head of Loch Eil* (no.13) by Macneill Macleay and *Machrihanish, Bay Voyach* (1893) and *The Barley Field, Sandy Dean* (1905) by William McTaggart, both of which were lent to the National Gallery of Scotland's McTaggart exhibition in 1989. Subsequent acquisitions included the atmospheric *Skaters: Duddingston Loch by Moonlight* (no.11) by Charles Lees in 1980, *Craigmillar Castle* (1861) by Waller Hugh Paton in 1983 and *View of the Clyde from Faifley and Duntocher* (no.2) by John Knox in 1984.

At the beginning of the 1970s David started to add the early work of the Glasgow Boys. E. A. Walton's *The White Horse* (c.1898), owned at one time by the noted Edinburgh collector J. J. Cowan and exhibited in London, Rome and Pittsburgh, was purchased in 1972. Walton, perhaps the most consistent of the Boys, is represented by six oils in the collection (see nos.33 & 34). Other notable additions were John Lavery's early *Bridge at Hesterworth, Shropshire* (no.29) in 1975 and the wonderful pastel by George Henry *Girl Reading* (no.31) in 1978. D. Y. Cameron, a younger contemporary of the Boys was a favourite of David Donald. Cameron's dramatic oil *The Boddin, Angus* (no.41) was purchased in 1977. The collection has thirty works by this under-rated artist, now largely ignored south of the Border, but who was an Academician of both the Royal Academy and the Royal Scottish Academy. He is seen at his best in his keenly observed watercolours, such as *Berwick-on-Tweed* (no.39) and the rather sinister *Peaks of Arran* (no.42), which betrays his etching origins, purchased in 1971 and 1976 respectively.

Although outside the scope of this exhibition, a substantial part of the collection comprises art from 1930 to the present day. Anne Redpath was another of David Donald's favourite artists. From 1970 to 1983 he purchased twenty-six works by Redpath. They chart her career from her return to Scotland from France in 1934 to her death in 1965: still-lifes and landscapes of Scotland and the Canary Islands, richly ornate Mediterranean altars and watercolour sketches of Spanish buildings. Her contemporaries William Gillies, William MacTaggart and John Maxwell are also represented, albeit on a smaller scale, as are the

9

expressionistic seascapes of Joan Eardley and the exuberant paintings of Robin Philipson.

The work of living artists was purchased at the annual exhibitions of the Royal Scottish Academy, the Society of Scottish Artists, the Aberdeen Artists' Society and occasionally the Royal Academy. But it was from dealers that David bought most of the collection. The Scottish Gallery in Edinburgh, Gillian Raffles of the Mercury Gallery and Priscilla Anderson of the Thackeray Gallery in London provided many of the paintings by living artists. Elizabeth Blackadder, Victoria Crowe, David Donaldson, James Fairgrieve, John Houston, David McClure, David Michie, James Morrison, Alberto Morrocco and James McIntosh Patrick are Academicians well represented in the collection, as are the minutely detailed paintings of John Gardiner Crawford, the semi-abstracted landscapes of Mardi Barrie and the harbour scenes of Donald McIntyre.

David Donald retired from Flemings in 1984, but continued to be responsible for the collection. He was a very cultured man with many interests, a ready wit and a Puckish sense of humour. He loved showing the paintings to fellow enthusiasts. Unannounced he would breeze in to meeting rooms filled with clients, dressed in a rather loud check suit as if he was on his way to open a book at his local Plumpton Racecourse, and would proceed to hold forth on the pictures to visitors and clients alike. New acquisitions would be shown to directors, secretaries – indeed, anyone he came across – and he would ask their opinion, not at all put out if occasionally the reaction was less than enthusiastic.

Sadly, in 1985, after only a year of retirement, David Donald died unexpectedly following a short illness. Earlier that year he had been accorded a rare honour, when he was elected an Honorary Academician of the Royal Scottish Academy for his services to Scottish art. His death left a gap which was virtually impossible to fill. There was no one with David's breadth of knowledge or, quite possibly, his eye for art. Robin Fleming, who had assumed directorial responsibility for the collection on David's retirement, asked me whether I would like to help with the collection. I jumped at the chance!

Joan Eardley *A Field of Barley by the Sea*

A VOYAGE OF DISCOVERY

When I joined Flemings thirty years ago I had no great enthusiasm for art. However, seeing the collection gradually building up around me, I began to take an interest. Being a Scot added a further dimension. An interest soon became a passion. In October 1992 I took early retirement from Flemings Corporate Finance Department to concentrate on the collection.

The first major task which Robin Fleming and I faced at the beginning of 1986 was to organise the transfer of the collection from Crosby Square to our present headquarters in Copthall Avenue. Flemings had long outgrown its offices in Crosby Square and had been forced to take further space in a nearby office block. It was considered important that all the bank's departments should be accommodated in the same building. A site was obtained on the opposite side of the Square Mile and a new building designed by Fitzroy Robinson & Partners gradually took shape. A term of the architect's brief was to take account of our collection when designing the building in order to display the paintings to the best advantage. This was achieved to stunning effect. Indeed, most visitors to the building are not prepared for what greets them beyond the narrow, mean City street and the unpretentious marble-clad entrance hall. The six floors of offices surround a glass-walled atrium topped with a glass roof and are served by glass lifts. Thus the visitor sees a series of galleries hung with works of art as the lift ascends. At almost any point on any of the galleries one can look across, up or down and see paintings. Even for someone who has worked in the building for some time the effect remains rather wonderful. Conservation of the paintings, however, can be a problem. Obviously, people are more important than pictures and an environment suited to the former can have an adverse effect on the latter.

Moving about 450 paintings from one office to another was relatively easy, compared with deciding where each should hang. The problem was compounded by the fact that the decorators had not finished some areas by the time

John Maxwell *Corner Table* 1954

we moved in and was further complicated by the obvious necessity of carrying on the business of the bank immediately on entry. Despite these difficulties, the hanging was completed within a fortnight, though not without a fair amount of anxiety and self-doubt.

Over the ten years during which Robin Fleming and I have been responsible for the collection the original guidelines have not been changed. However, the emphasis has been placed on collecting the work of living artists. There are two main reasons for this. First, we were relatively underweight in contemporary art, and, second, the cost of such art on average is much less than that of paintings by McTaggart, Peploe and the like. In contrast to the more relaxed financial regime which prevailed in the early years of the collection, a budgetary system was now in operation and costs had come under much stricter scrutiny. Buying paintings is hardly a core activity of the bank and the shareholders would, with reason, have cause for concern if the cost of such paintings was any more than a very insignifi-

cant part of the bank's expenses. Indeed, the question of whether *any* paintings should be purchased during a period when business is contracting or salaries are restricted is a very difficult one. The popular notion of a cash-rich corporate collector throwing money at the art market could not be further from reality.

During the period since David Donald's death the work of Academicians such as the current President William Baillie, Gordon Bryce, William Littlejohn, Will McLean, Barbara Rae, Duncan Shanks and Ian McKenzie Smith has been added to the collection. John Bellany is now represented by three early oils and a recent watercolour. But the main thrust has been directed towards younger artists. The New Glasgow Boys are represented by Stephen Barclay, Steven Campbell, Stephen Conroy and Peter Howson; a head by Ken Currie has been added very recently. Other artists added to the collection include Gary Anderson, Derrick Guild, Ian Hughes, Keith McIntyre, Peter McLaren, Craig Mulholland, June Redfern, Peter White

John Bellany *The Ettrick Shepherd* 1967

and Jock McFadyen, whose 'fun' painting *Hawksmoor and Golden Wonder* (*c.*1988) perhaps more than any other is either loved or hated by staff.

As well as increasing holdings of contemporary art, we have filled gaps and strengthened sectors in the traditional collection as suitable opportunities have occurred. Five major acquisitions have been made. James Pryde was added to the collection when we bought *The Unknown Corner* (no.44) in 1988. The following year we purchased William McTaggart's *The Village, Whitehouse* (no.20), funded by the sale of a Peploe, followed a year later by the addition of a pair of early McTaggarts *Morning, Going to the Fishing* (no.18) and *Evening, Return from the Fishing* (no.19), purchased from a private collection in the south of England which had held them for almost a century. In 1991 we bought *Window in Menton* (1948), one of Anne Redpath's finest paintings, and a group of paintings by Dorothy Johnstone, Eric Robertson and D. M. Sutherland, all members of the Edinburgh Group.

Many artists not previously represented in the collection have been added, including Alexander Nasmyth (no.1), Alexander Fraser Snr (no.6), George Paul Chalmers (no.17), Robert McGregor, Flora Macdonald Reid (no.35) and her brother John Robertson Reid (no.23), Edwin Alexander (no.45) and John Duncan (no.43). The Glasgow Boys have been further strengthened by the purchase of Arthur Melville's fine watercolour *The Orange Market, Saragossa* (no.28) and the addition of James Nairn (no.32) and E. A. Hornel (no.36). Two of Hornel's fellow artists in Kirkcudbright, W. S. MacGeorge and Charles Oppenheimer, have also been added. The most recent significant purchase is James Gunn's *The Eve of the Battle of the Somme* (no.60), which was included in the Gunn exhibition at the Scottish National Portrait Gallery this year.

There are still many gaps to be filled. Neither Allan Ramsay nor Henry Raeburn are represented in the collection. James Guthrie is a notable absentee from the Glasgow Boys and there is nothing by Charles Rennie Mackintosh.

Anne Redpath *Window in Menton* 1948

Many visitors are surprised that Landseer does not feature in the collection. In fact David Donald did purchase a painting by Landseer, depicting a terrier attacking a hedgehog, which was hung in the directors' dining room opposite a large work by Richard Ansdell of ghillies bringing down stags shot on the hill, slung over the backs of two stalking ponies. However, a number of David's colleagues complained that the sight of so many animals, dead or alive, upset the flow of their gastric juices! Ironically, but perhaps not surprisingly given the subject matter, the Ansdell was retained and the Landseer was sold.

Sculpture too needs to be expanded. We purchased J. D. Fergusson's brass head *Eastre, Hymn to the Sun* in 1988. There are several small pieces, mostly animals and birds, by sculptors such as Sally Arnup, Phyllis Bone, Mary Fleming, Shona Kinloch and Jillian Watson. Recently we added a small version in bronze of Eduardo Paolozzi's *Newton Measuring the World, after William Blake.*

Of course, there is no pressure on us to have a truly representative collection of Scottish art, in contrast to the situation faced by a national collection. On the other hand, it gives us great satisfaction when we are able to add a new artist to the collection – for us collecting is very much an exciting voyage of discovery. We have also a greater freedom in the choice of individual paintings than has a national collection. We can buy what we like. Indeed, David Donald was not above ignoring the collection's Scottish guidelines to acquire a picture that he admired, such as *The Pink Umbrella*, a watercolour by the American artist Milton Avery. We can opt for rarities, such as an oil by Copley Fielding or a painting which is not truly representative of an artist's work, like the Gunn mentioned above. We have also no problem with regard to de-accessioning. Although sales have been infrequent so far, they are likely to increase as the collection matures and works are upgraded or mistakes reversed.

William Johnstone *Entombment* 1972

PRINCIPLES AND AIMS

From the beginning it was decided that Flemings should not retain an external art adviser, as a number of corporate collections do, but would itself take all the decisions about what policy to follow and what to buy. Of course, we have been helped by many dealers, especially by The Fine Art Society in London in the early years and latterly by Bourne Fine Art in Edinburgh. It was agreed also that acquisitions (and hanging) should be left to one person, or two at the most, rather than a committee. It was felt that a committee would never agree and could end up buying everyone's second or third choice on the lowest common denominator principle. Thus decisions can be taken very quickly. It also makes for a more personal collection, even although in the wrong hands it can result in a rather idiosyncratic one. The collection has a feeling of intimacy, which is enhanced by the relatively small size of many of the paintings, for instance those by the Scottish Colourists, and by where they are hung. The scale of many of the dining rooms and their pictures suggest a private house, rather than the offices of a bank.

The aims of the collection remain very similar to what they were at the outset in 1968. The paintings have been purchased not as an investment (although, of course, they do form part of the bank's *hidden assets*), but as a means of promoting a more stimulating working environment in which to carry on our investment banking business. At the same time we want to foster Scottish art and encourage young Scottish artists.

In choosing work for purchase, we have tried to a limited extent to challenge as well as to entertain. Of course, this is rather subjective. Some of the staff find the landscapes of Joan Eardley or the later work of Anne Redpath rather difficult, whereas others thrill at the wonderful colour of William Johnstone's semi-abstract painting *Entombment*, purchased in 1991, or at the expressionism of Margaret Hunter's *Linking Lucy*, purchased in 1993. We have also added several abstract works to a collection which for over twenty years had been totally figurative. Not surprisingly, some are more successful than others. We are very conscious that the collection must be kept alive and moving forward. However, we are torn between sticking to something we know well and moving into new territory. Perhaps our innate conservatism is both the strength and the weakness of the collection. The preparation for this exhibition, the choosing of works to be exhibited, the reactions and comments of Helen Smailes and Mungo Campbell of the National Gallery of Scotland have all stimulated thought on these matters and will help us in the formulation of future policy.

The success (or otherwise) of the collection should not be measured in monetary terms, but in the reaction to it of staff and visitors. In general, the response from both has been very positive. Although there is a wide range of opinions about many of the paintings, the staff appreciate working in an environment in which original works of art are hung on the walls. New additions always evoke comment. Whether that comment is favourable or unfavourable is of secondary importance to the fact that staff have stopped in front of a picture and taken time to consider it. Some of the paintings are moved around from time to time and considerable heat can be generated by staff if a favourite painting is moved on! The collection has led to many of the staff taking a deeper interest in art and, for some, going on to become collectors themselves, even in a very modest way. Surely that is the true measure of success.

1

ALEXANDER NASMYTH HRSA
1758–1840

A Stormy Highland Scene

Oil on canvas, 36 × 48in (91.5 × 122cm)
Purchased 1992

Nasmyth's pre-eminence as 'the founder of the landscape painting school of Scotland' in the late 18th and early 19th centuries has remained essentially unchallenged since Wilkie's posthumous tribute. The son of an Edinburgh master-builder, Nasmyth studied at the Trustees' Academy under Alexander Runciman, while serving an apprenticeship to a local house-painter, James Cummyng. In their turn, both of Nasmyth's masters had trained with the Norie family, the leading firm of house-painters which had also pioneered the art of landscape painting in Scotland. In 1774 Nasmyth was employed by Allan Ramsay as a specialist drapery painter in his London studio before establishing his own successful portrait practice in Edinburgh. During the 1790s, following an important interlude in Italy, Nasmyth evolved his most influential type of landscape painting – large-scale panoramic views of Scottish country houses and castles in which topographical accuracy was united with a distinctive picturesque sensibility. Nasmyth's manner was widely disseminated through his classes for amateur and professional artists which were held at his custom-built premises at 47 York Place in Edinburgh, and through his daughters and his son Patrick, all of whom achieved some independent recognition as landscape painters.

Nasmyth's stormy 'Highland' landscape might be described as a capriccio on the theme of Culzean Castle in Ayrshire in which the castle itself has been further 'gothicised' and the Island of Arran apparently moved southwards in order to furnish a dramatic backdrop. Two views of Culzean which were commissioned by the Earl of Cassillis for his picture gallery in 1812 present a striking contrast to this picture and another version of the same composition with a foreground group of figures in mediaevalising costume. During the 1790s when his portrait business had declined as a result of his own political radicalism and vigorous competition from Raeburn, Nasmyth had diversified into the provision of stock scenery for the Edinburgh and Glasgow theatres and for Drury Lane. His last commission of this type, for *The Heart of Midlothian* in 1819, coincided with the vogue for dramatisations of the Waverley Novels which he was also engaged to illustrate for the publisher Constable. This extraordinary capriccio may or may not have been inspired by Scott. Its whole conception is simultaneously Romantic and retrospective, drawing on the classicising conventions of decorative landscape painting and theatrical scene painting which Nasmyth had first inherited from the Nories.

16

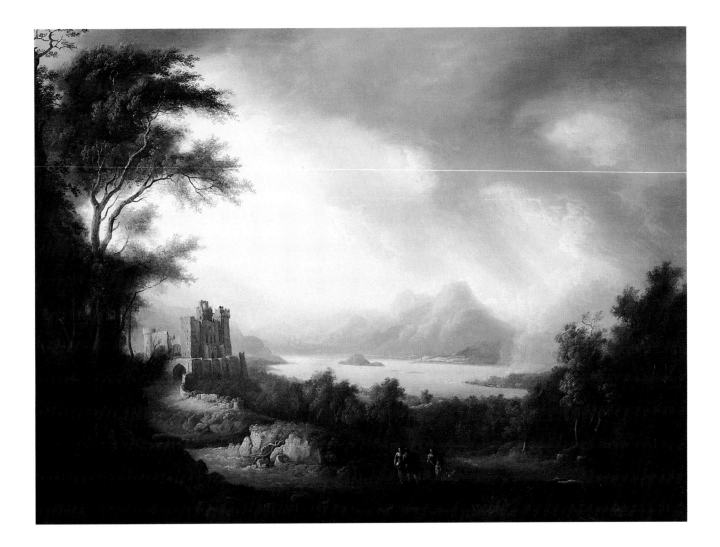

2

JOHN KNOX
1778–1845

View of the Clyde from Faifley and Duntocher,
looking South-West towards Dumbarton Rock

Oil on canvas, 36 × 58in (91.4 × 147.2cm)
Purchased 1984

An obscure and yet surprisingly influential figure in the evolution of early 19th-century Scottish landscape painting, Knox was raised in Paisley and migrated to Glasgow where, by 1809, he was specialising in portraiture. By 1821, when he showed *A View of the Clyde from Dalnottar Hill* at the inaugural exhibition of the Glasgow Institution, he was in demand as a landscape painter, noted both for the sweeping breadth of his effects and his precise rendering of specific topographical detail. These qualities found their most impressive expression in a pair of panoramic views from Ben Lomond of which one set was acquired by the Duke of Hamilton. Through his drawing-classes in Glasgow, attended by Horatio McCulloch, William Leighton Leitch and Daniel Macnee, Knox's ideas were transmitted to the next generation of landscape and portrait painters.

Many of Knox's views, including this one, have long been dissociated from their original context and have even forfeited their correct titles. With its distinctive conformation and wealth of historical associations, Dumbarton Rock had held a particular appeal for artists since the late 17th century. Here both the Rock itself and the surrounding countryside are transfigured by a blaze of golden light, creating a poetic vision of the Vale of Leven within the clas-

sical tradition of landscape painting ultimately derived from the work of Claude Lorrain. Yet this pastoral mode evoked by the presence of the faggot gatherers and the grazing cattle is qualified by the prominence given by Knox to the extensive mills occupying the middle ground of the picture. This has recently been re-identified as a prospect of Faifley and Duntocher.

The Industrial Revolution had started in Dunbartonshire towards the end of the previous century. By the 1820s the Vale of Leven was becoming established as the principal centre of the finishing processes of textile manufacture. Between 1808 and 1831 William Dunn of Kirkintilloch, a smith and manufacturer of cotton machinery, developed a complex of four spinning and weaving mills at Faifley, Duntocher, Milton and Hardgate. Through his enterprise Dunn transformed the ailing local economy and was widely recognised as one of the most remarkable of the new industrialists. Dunn's prosperity had enabled him to acquire large tracts of arable and grazing land. Is it conceivable that he commissioned Knox to paint the definitive record of the transformation of the landscape in which he had played such a significant role?

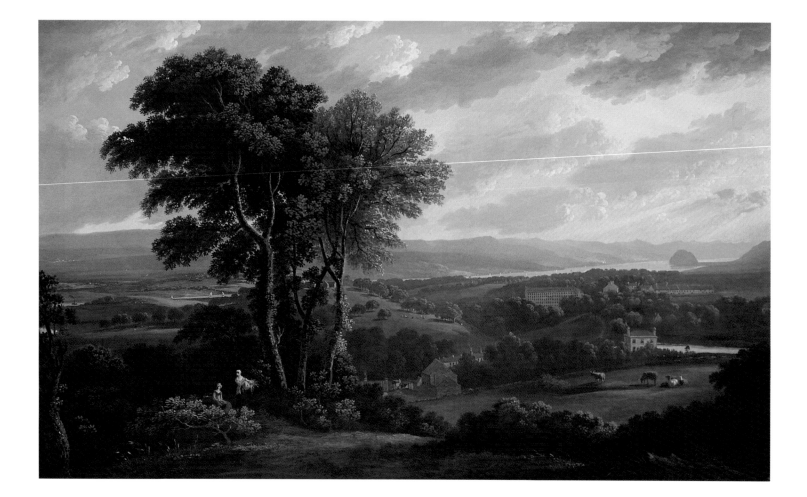

3

SIR DAVID WILKIE RA
1785–1841
The Village School

Oil on panel, 40 × 60in (101.6 × 152.4cm)

In September 1815 the Marquess of Stafford assured Wilkie of his intention of inspecting a sketch for *The Village School*. The expected commission, which did not materialise, would have been extremely prestigious. One of the foremost connoisseurs of the day, Stafford had inherited the magnificent group of Raphaels, Titians and Poussins which now constitute the core of the Sutherland Loan to the National Gallery of Scotland, but were then displayed at Cleveland House with other paintings purchased from the Orléans collection. In 1821, following an abortive approach to the Marquess of Lansdowne, Wilkie received a firm offer from the Staffordshire MP and collector of British painting, Jesse Watts Russell. In 1825, however, progress with the commission was further disrupted by Wilkie's breakdown and subsequent departure for Europe and the picture was eventually left unfinished.

Wilkie's *School* was the lineal successor of the peasant genre paintings with which he had begun his meteoric rise to fame on moving to London in 1805. The subject lent itself to the multiplication of sub-plots and incidental detail and above all to the portrayal of psychological interaction between diverse groups. Wilkie's skills in this dimension had earned him prodigious success with *The Village Politicians* which, in Haydon's estimation, revolutionised British genre painting.

Wilkie's biographer, Allan Cunningham, identified the setting of the *School* as being Kingskettle School in Fife where the artist, the son of the minister of Cults, was remembered for his 'singularity' and his involvement in 'all the idle mischief that was at hand'. Rather than a literal transcription, the picture probably represents an inventive transmutation of various childhood experiences, including even earlier recollections of the school at nearby Pitlessie.

According to Wilkie's engraver, John Burnet, he habitually frequented the Stafford gallery and other private collections in London, 'everywhere peering into the works of the Dutch and Flemish schools'. Given his capacity for creative appropriation from Old Master painting, Wilkie cannot have ignored such an obvious precedent for his own *Village School* as the many spirited interpretations of the theme by Jan Steen (1626–1679). Wilkie may well have seen the three Steens of this type which were exhibited in 1815, 1818 and 1819 at the British Institution in London and of which the first exhibited and most elaborate is now in the National Gallery of Scotland.

20

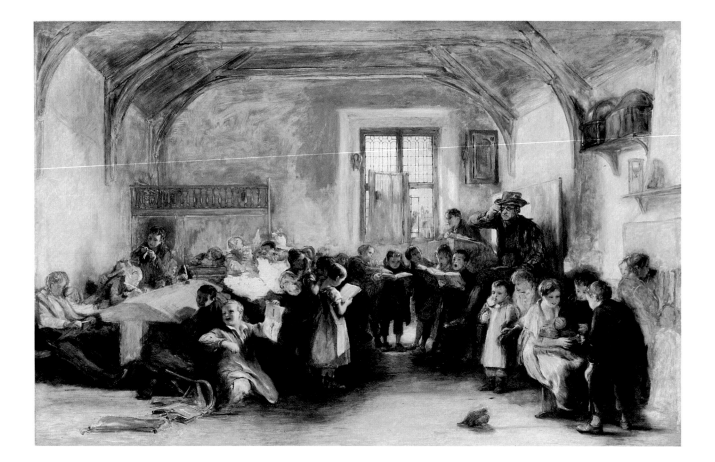

4

SIR DAVID WILKIE RA
1785–1841
The Spanish Mother

Oil on canvas, 39 × 50in (99 × 127cm)

From 1825 to 1828 Wilkie travelled extensively in Europe in an attempt to recuperate from a nervous breakdown. Of his final destination he wrote from Madrid that Spain was 'the wild unpoached game reserve of Europe'. The first significant British painter of his generation to visit Spain, Wilkie would be followed by Roberts and J. F. Lewis in 1832 and William Allan in 1834. In Madrid – which he explored in the company of Washington Irving, then attached to the American Legation – Wilkie sought out Titian and Velázquez in the 'game reserve' of the Prado and the Escorial, whereas in Seville he concentrated on Murillo. This tour proved to be of catalytic significance in initiating a thematic and stylistic evolution in Wilkie's art. His abandonment of his earlier anecdotal narrative subject matter was accompanied by a new breadth and fullness in composition, rendered with resonant chiaroscuro and a luminous richness of texture which was informed by his recent familiarisation with the Venetian schools and Correggio.

Of the series of pictures either conceived or begun in Spain, three were completed by royal command prior to their exhibition at the Royal Academy in 1829. This remarkable act of patronage was probably due to the intermediation of Sir William Knighton, physician and confidant to George IV and a connoisseur of painting in his own right. Knighton, who had attended Wellington (when Marquess of Wellesley) on his embassy to Spain in 1809, took an informed interest in Wilkie's Spanish pictures.

In 1833 Sir William commissioned *The Spanish Mother* which was exhibited to great acclaim at the Royal Academy in the following year. The King's most substantial purchase had been Wilkie's *The Defence of Saragossa*, commemorating a striking episode of personal heroism during the Spanish insurrection against Napoleonic occupation in 1808. Among the Wilkie drawings in the Ashmolean Museum is a chalk study, made in Seville in April 1828. This depicts a grieving mother and child attended by a uniformed officer on a gun emplacement. From this drawing – which may be thematically related to his Saragossa picture – Wilkie extracted the essential idea for Sir William's commission, while simultaneously transforming its meaning and context. Despite the apparent contemporaneity of Wilkie's subject, many of the compositional formulae of this picture – the pyramidal structure of the life-size group, the child's playful and tender gesture and the atmospheric landscape glimpsed through a 'Moorish' window embrasure – have precedents in traditional representations of the Holy Family from the Renaissance onwards.

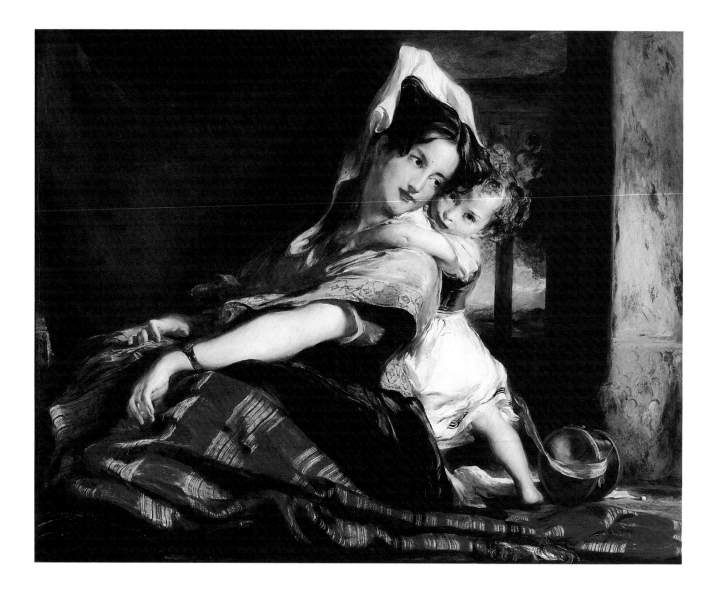

5

SIR DAVID WILKIE RA
1785–1841

Columbus and Queen Isabella

Pen and watercolour, 6¼ × 6½in (15.8 × 16.5cm)
Signed and dated *1836*
Purchased 1981

For several years after his return to London, Wilkie's experiences in Spain continued to provide material for his paintings. He had met the American writer, Washington Irving, who was then working on a biography of Christopher Columbus, on the day of his arrival in Madrid. Irving apparently soon told Wilkie the story of the encounter between the Genoese adventurer and the Prior of the Franciscan monastery of La Rábida which set Columbus's expedition in motion. That encounter became the subject of a picture apparently first sketched by Wilkie while still in Spain but not started upon until the middle of 1834. By the time that *Columbus at the Convent of La Rábida*, (North Carolina Museum of Art) was exhibited at the Royal Academy in 1835, Wilkie appears already to have been contemplating a pendant picture on the subject of Queen Isabella offering her jewels to help pay for the expedition. Wilkie seems to have found little to motivate him in the development of the project until early in 1836, when Washington

Irving wrote to inform him that a friend wished to commission a copy of the first Columbus picture. Wilkie replied that he would prefer to paint an original work and, although no specific subject for the new picture is mentioned, the date of the present drawing would suggest that the idea of Columbus's explanation of his project to the Queen, again surfaced at this stage. In fact, although a canvas was prepared for the painting, it was never started.

While in the Iberian peninsular, freed from the creative block which had overtaken him prior to his journey, Wilkie had begun to develop faster techniques of bringing his ideas to the canvas, working sketches up with watercolour washes, instead of his former practice of following a series of Rembrandtesque compositional pen drawings with detailed, Rubensian chalk figure studies. In this charming drawing, made some nine years after leaving Spain, Wilkie's mastery of both line and wash is superbly demonstrated.

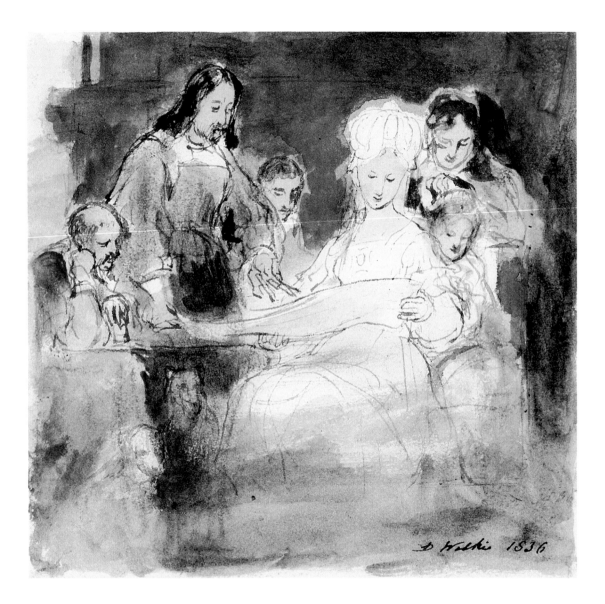

6

ALEXANDER FRASER SENIOR ARSA
1786–1865

A Scene at Newhaven

Oil on canvas, 28 × 44in (71.2 × 111.8cm)
Signed and indistinctly dated *1841*
Purchased 1994

One of the most gifted of Wilkie's fellow-students at the Trustees' Academy, Fraser followed him to London in 1813. For twenty years Wilkie employed him as a specialist assistant for still-life accessories and on at least one occasion passed on a commission for a genre picture. In London Fraser was assured of an appreciative market for his independently executed genre paintings. Among the many fishing subjects which he exhibited both at the London and Edinburgh Academies, several were of Scottish inspiration.

By the 1840s the fishing village of Newhaven on the Firth of Forth was a highly popular tourist attraction, readily accessible from Edinburgh and even from London, either by stagecoach or by steam packet. The travellers who purchased ceramic figures of Newhaven fishwives were fascinated by the distinctive costume, culture and traditions perpetuated by this largely self-contained community. Newhaven owed its original prosperity to the patronage of James IV. The Flemish community of craftsmen employed on the construction of his warship, the Great Michael, was supplemented by an influx of refugees from the Spanish Netherlands. Their arrival gave fresh impetus to the indigenous fishing industry. Newhaven became famous for its

seasonal herring fishery, as immortalised in Lady Nairne's song 'Caller Herrin', and from 1816 it enjoyed literary celebrity as the home of the Mucklebackit family in Scott's novel, *The Antiquary*.

Newhaven's continental associations were most memorably preserved in the picturesque costume of the fishwives. In his novel *Christie Johnstone* composed in 1850, Charles Reade encapsulated their varied attractions for artists in the form of a romance between the beautiful young fishwife, Christie, and the Newcastle-born Charles Gatty, who settles in Edinburgh as a champion of *plein air* landscape painting! Fraser's response was equally personal, although in a somewhat different sense. His picture is conceived in the idiom of Netherlandish genre paintings of fishmarkets by the sea. At the same time his pictorial microcosm of Newhaven life is utterly localised in detail. As noted by *The Scotsman* in 1842, Fraser's principal fishwife with her creel is an identifiable individual. The same is probably true of her companions, engaged in shelling mussels for baiting the lines. In the foreground, discarded oyster shells recall the immense importance of the winter occupation of oyster-dredging.

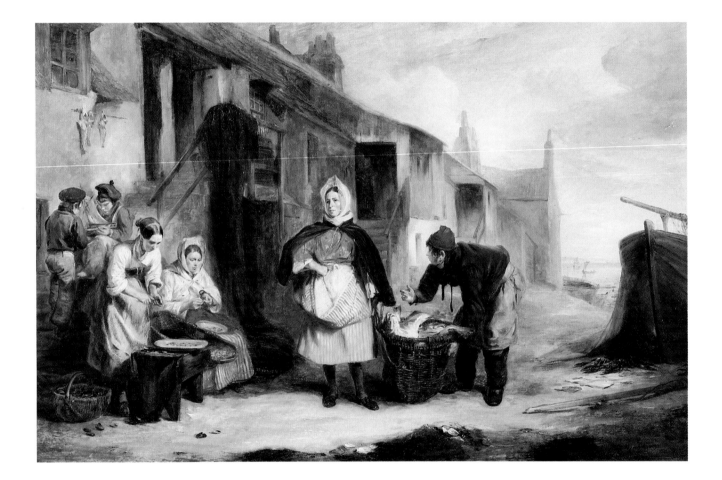

7

ANTHONY VANDYKE COPLEY FIELDING PRWS
1787–1855

Inverary

Oil on canvas, 22 × 29½in (55.8 × 74.9cm)
Purchased 1957

Named auspiciously, if rather pompously, in honour of Sir Anthony van Dyck and the contemporary American history painter John Singleton Copley RA, Copley Fielding was born in East Sowerby near Halifax, the second son of a minor portrait and landscape painter. From 1810, after studying with the London-based watercolourist John Varley, he rapidly established himself as the most prolific exhibitor at the Old Watercolour Society, of which he held the Presidency from 1831 to 1855. Although given to formulaic composition, Copley Fielding was renowned for the facility of his handling of the watercolour medium and for his exquisite colour harmonies, qualities which also characterised his occasional experiments with larger-scale oil painting.

Following his first sketching tour to the Lakes and Scotland in or about 1810, he regularly exhibited West Highland subjects, including several views of Inverary and its locality in 1825, 1828, 1831 and 1846. This undated prospect of Inverary and the wooded slopes of Dun Na Cuaiche, viewed from the south-west across Loch Fyne, is a studio composition which was probably worked up in the late 1820s or early 1830s from graphite sketches executed direct from nature. Once considered a remote backwater, this small provincial capital had become a popular summer resort for the English or foreign gentleman tourist in quest of the sublime picturesque. During the previous century the Royal Burgh of Inverary – which was also the principal seat of the Dukes of Argyll – had been transformed by the construction of the military or 'Kings' road during the Forty-Five Rising and the building of a new castle and re-location of the town by the third Duke of Argyll. Among the many artists who converged on the new Inverary were Alexander Nasmyth, Joseph Farington and J. M. W. Turner (all, independently, in 1801) and, in 1817, David Wilkie.

Paradoxically, Copley Fielding interpreted the actual scene retrospectively by eliminating any material evidence of the third Duke's pioneering initiative in urban planning, apart from the distinctive Aray Bridge, as designed by Robert Mylne in 1773. In order to enhance the expressive grandeur of the landscape he also exaggerated the height of the hills and the scale of the bay. The sole intruders into his unspoiled wilderness are probably netting salmon, an unconventional choice of subject matter since the staple industry of Inverary was actually the herring fishery.

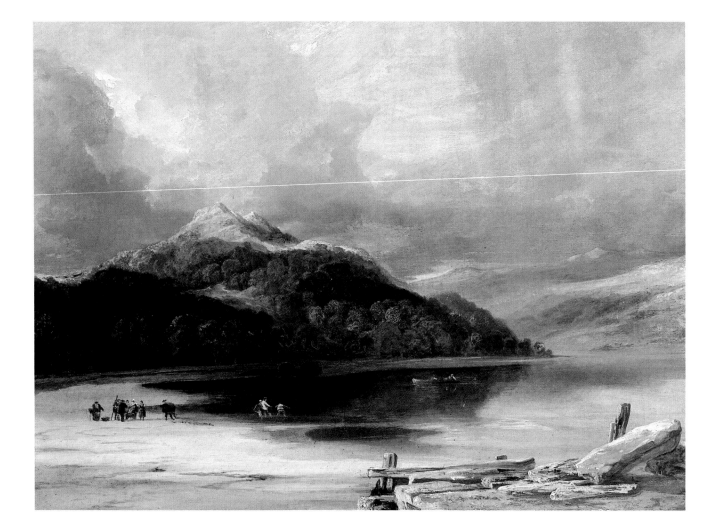

8

THOMAS SWORD GOOD
1789–1872

A Fisherman with a Gun

Oil on mahogany panel, 14⅛ × 11½in (36.2 × 29.3cm)
Inscribed with the artist's name and indistinctly dated *1825*
Purchased 1968

In 1810, having served an apprenticeship with a painter-decorator in his native Berwick, Good set up his own business in London where Wilkie had settled five years previously. While in London, Good would have had every opportunity to acquaint himself with the latest developments in genre painting at the exhibitions of the Royal Academy and the British Institution. Two years later, the death of his father prompted his return to Berwick where he lived with his mother for the next twenty years, travelling periodically to London for the opening of the Academy exhibition. His father's inheritance probably enabled him to abandon his trade for the otherwise precarious alternative of a career as a portrait and genre painter in the isolated outpost of Berwick. From 1820 he exhibited widely at the Royal Academy, the British Institution and a number of regional centres until 1834 when he ceased to paint on a regular basis following a late marriage to a local heiress.

In Newcastle-upon-Tyne, where the first public art exhibition was arranged in 1822, Good's small 'fancy pictures' with their high finish reminiscent of 17th-century Netherlandish genre painting found a particularly appreciative audience. His *Fisherman* caused a sensation at the exhibition of the Northumberland Institution for the Promotion of Fine Arts in 1825. Subsequently, several Newcastle artists imitated his singular device of using exaggerated side-lighting to define facial features or fold-lines of drapery. Good's obsessional preoccupation with novel lighting effects, which was later censured as a restrictive mannerism, may have been nurtured by his encounter with the portraiture of two eminent Edinburgh artists, Sir Henry Raeburn and George Watson. The second show of the Edinburgh Exhibition Society, in which Good had made his debut as a professional artist in 1815, had been staged in Raeburn's studio.

Invested with an almost theatrical intensity, Good's studies of the Berwickshire fishing community were apparently devoid of social comment. This element of contrivance was enhanced by his preference for employing members of his immediate family as models. In this case, his older brother Robert, one of his favourite models, posed for the fisherman. Robert was a man of equally distinctive and some artistic inclinations whose business interests encompassed those of grocer, artists' colourman, ships' chandler and, latterly, photographer.

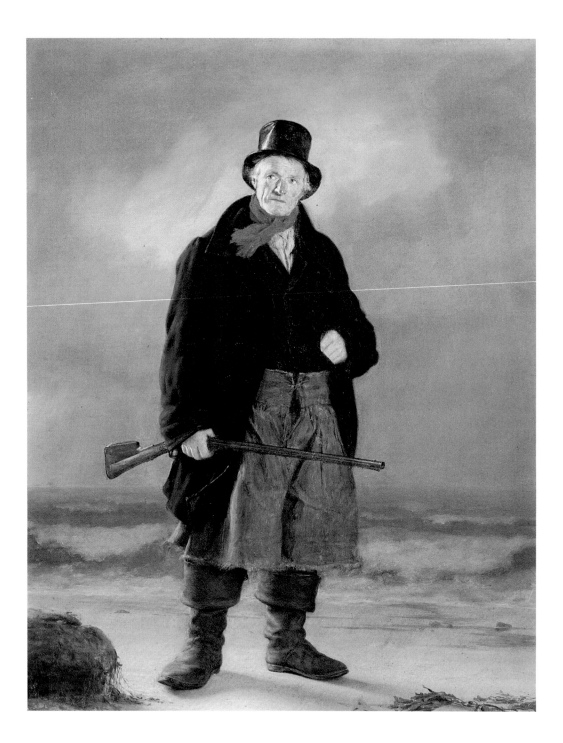

9

THOMAS SWORD GOOD
1789–1872

Coast Scene with Figures Mending Nets

Oil on mahogany panel, 16⅜ × 22½in (41.6 × 57.1cm)
Purchased 1982

Good was one of the most idiosyncratic members of the first generation of English and Scottish genre painters to be influenced by the enormous prestige enjoyed by Wilkie. Titles such as *The Village Politician* were clearly intended to focus public attention on this artistic affiliation by recalling Wilkie's resounding success in 1806 with *The Village Politicians*. In general, Good remained committed to a very limited range of localised subject matter connected with the reputation of his native Berwick for its coastal fisheries and incomparable facilities for salmon fishing on the Tweed. Yet, his apparently introverted preference for studies of fisherfolk – here actually depicted mending a sail rather than fishing nets – and smugglers must have been informed by an acute commercial awareness of their topicality.

The second two decades of the 19th century witnessed the establishment of an axis linking newly formed exhibiting bodies in the major provincial centres of northern England, such as Newcastle-upon-Tyne, Manchester and Liverpool, with their counterparts in Edinburgh and Glasgow. This institutional interchange opened up opportunities for patronage while simultaneously fostering a community of artistic interests. Good varied his options from London to Newcastle and Edinburgh. Between 1828 and 1833 he regularly exhibited his studies of fisherfolk at the Royal Scottish Academy of which he was elected an honorary Academician in 1828 and of which William Nicholson (a native of Newcastle who had settled in Scotland) was then Secretary. At these exhibitions Good purchased a number of pictures by his Edinburgh contemporaries including Shiells, Alexander Fraser and J. W. Ewbank. Parallels for Good's particular preoccupations in subject matter may be found among the work of several of the Scottish followers of Wilkie, notably Alexander Fraser senior (see no.6) and William Kidd whose *Fisherfolk* is in the National Gallery of Scotland.

In London, at the Royal Academy, Good would have encountered paintings by William Shayer and William Collins, two of the most successful southern exponents of this genre. By comparison, the inherent weaknesses in Good's methods of composition would have been self-evident. In 1832 he exhibited a *Coast Scene with a Fisherman* into which he introduced a reversed image of the figure from *Fisherman with a Gun*. As in the present picture, he consistently failed to integrate his studio-posed and studio-lit models into their landscape settings. These settings, which are suggestive of theatrical backdrops, were actually elaborated from pencil or watercolour sketches executed direct from nature.

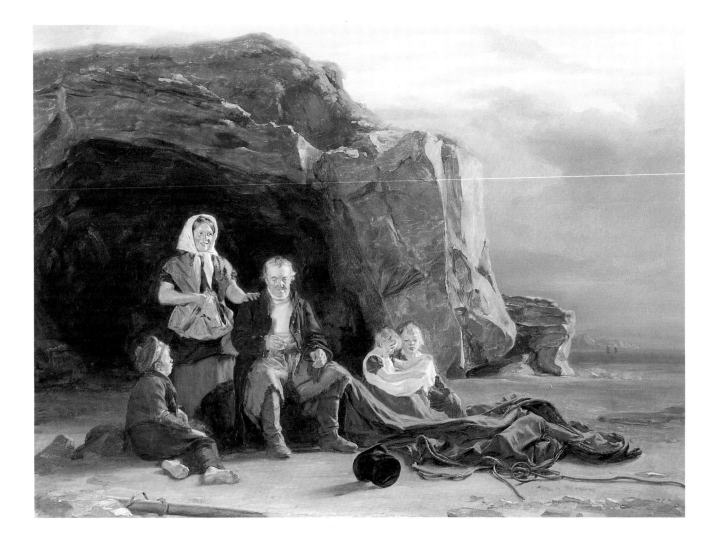

10

JOHN B. FLEMING
1792–1845

View of the Clyde from Dalnottar Hill

Oil on canvas, 28½ × 48in (72.3 × 121.8cm)
Signed and dated *1823*
Purchased 1978

As an apprentice housepainter in his native Glasgow, Fleming received his initial exposure to high art while working at Hamilton Palace with its outstanding collection of Old Masters. After practising his trade in London and familiarising himself with contemporary painting, he settled permanently in Greenock as the town's first residential professional artist. In addition to enjoying a near monopoly of local patronage for portraiture, he was soon in demand for his considerable skills as a topographical painter. In 1828 he collaborated with John Knox (see no.2) and the lithographer Joseph Swan in publishing a set of views of Glasgow. A second volume, issued about 1830 and devoted exclusively to Fleming's views of the Clyde, included one of three virtually identical prospects taken from Dalnottar Hill near the village of Old Kilpatrick.

The surpassing beauty and rich variety of this locality proved irresistible to 19th-century Scottish landscape painters. The surrounding hills of Dunbartonshire and Renfrewshire and the dark mountains of Argyll formed together 'a magnificent amphitheatre, in the centre of which roll the waters of the majestic Clyde, like a lake of almost boundless expanse.' In 1805 Nasmyth had reproduced the same scene on the celebrated drop curtain of Glasgow's old Theatre Royal and in 1821 Knox exhibited his version of the subject in Glasgow.

At one level Fleming presents a panoramic vision of the area as a latterday Arcadia, suffused with pale sunlight and framed by Claudian trees, carefully repositioned to suit the requirements of a harmonious composition. On the left of the picture is Lord Blantyre's newly erected rural retreat Erskine House and its pleasure grounds. It overlooks the river on which may be observed the new steam ships, all 'laden with the manufactures of Glasgow, or bringing in the riches of the East and of the West, destined for that commercial emporium.' In the foreground Fleming has carefully recorded another major innovation of the Industrial Revolution. Opened to navigation in 1790, the Forth and Clyde Canal ran from the port of Grangemouth in the east to the marina of Bowling on the Clyde. Its construction played a crucial role in the growth of manufacturing industries across central Scotland.

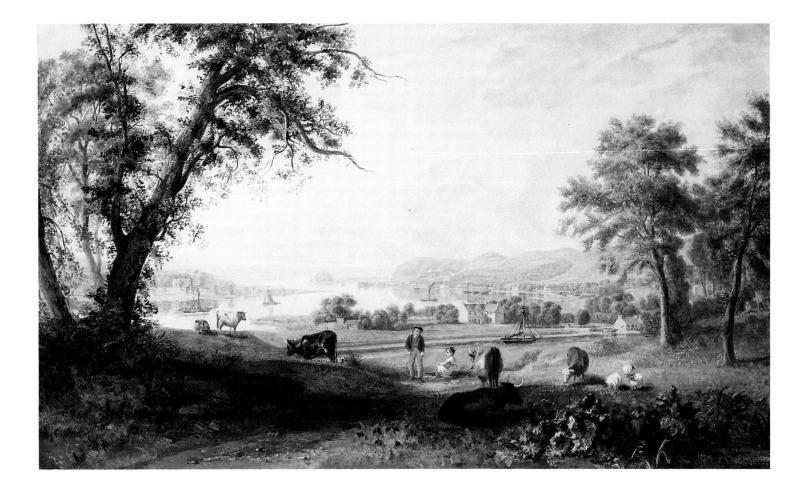

11

CHARLES LEES RSA
1800–1880

Skaters: Duddingston Loch by Moonlight

Oil on canvas, 20 × 29½in (50.8 × 74.9cm)
Signed and dated *1857*
Purchased 1980

A native of Cupar in Fife, Lees first secured employment as a drawing-master in Edinburgh where, like many contemporaries, he responded to the burgeoning demand for instruction for the amateur artist. Having resolved on a career in portraiture, he apparently received some tuition from Raeburn while also experimenting with history painting. By the 1840s, however, Lees was pursuing a sideline in sporting pictures, perhaps encouraged by Sir George Harvey's critical success with *The Curlers* which had been replicated in several versions since its first appearance in 1835. These subjects enabled Lees to explore his own sporting preoccupations in combination with pure landscape and character figure painting, occasionally on a monumental scale and in a manner strongly reminiscent of the Edinburgh street life studies of Walter Geikie.

The Edinburgh Skating Club, which usually convened at Lochend or Duddingston, enjoyed the patronage of Prince Albert and an unrivalled prestige as the oldest established club in Britain. Although not socially exclusive, its membership was dominated by the landed gentry and the legal aristocracy. The Club was noted for its commitment to figure skating, described by Lord Cockburn as 'the poetry of motion'. Among the disorderly skaters in Lees's picture, the most co-ordinated group appears to be practising a figure – probably in anticipation of alcoholic refreshment in a Club known for its conviviality! Also prominently displayed in the foreground is some life-saving apparatus as a poignant reminder of the risks of drowning, of which the Club was acutely aware.

Although not associated with the Club himself, Lees may have known of two memorable portraits of earlier members – the small full-lengths by Raeburn of the Reverend Robert Walker of the Canongate Kirk, painted about 1784 (National Gallery of Scotland), and by Geddes of the lawyer and one-time Club Secretary, Charles Knowles Robison, exhibited in 1821. Both were depicted in elegant action on Duddingston Loch. In addition, given Lees's own fascination with special lighting effects – he showed two moonlight views of St Andrews Cathedral in 1848 and 1849 – he must have been familiar with the moonlight scenes of winter sports by the 17th-century Amsterdam painter Aert van der Neer, so widely circulated through engraving. In 1854 Lees exhibited a daylight scene of skaters at Duddingston which is strikingly similar to the present one in its essential design. Surely he was inviting comparison with the technical virtuosity of van der Neer.

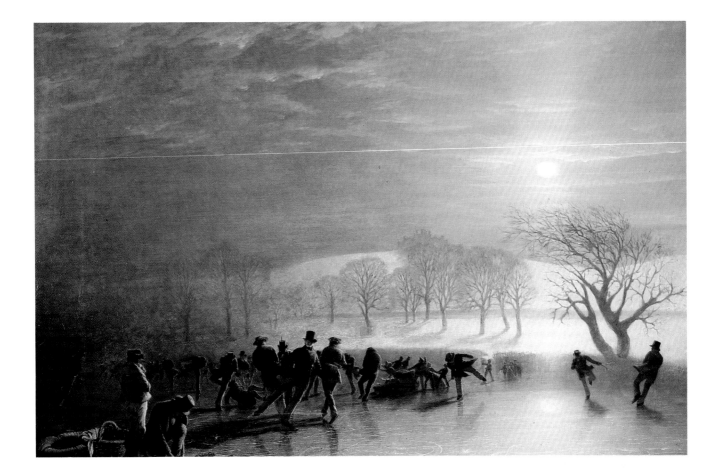

12

JAMES GILES RSA
1801–1870

Island of Handa, West Coast of Sutherland

Oil on canvas, 24 × 36in (61 × 91.4cm)
Purchased 1977

By the age of nineteen, although largely self-educated, Giles had already succeeded his father, a pattern designer for the Aberdonian cotton manufactory, in the well-tried profession of drawing-master. In 1823 he embarked on a challenging programme of self-improvement. An interlude in the Paris studio of J. B. Regnault was followed by intensive study of Old Master painting and prolific sketching from nature in Italy. On returning to Aberdeen, Giles formed the Aberdeen Artists Society of which he was elected President in acknowledgement of his status as the city's leading landscape and portrait painter. In 1829 he achieved similar recognition in Edinburgh on his election as an Academician.

Through his first influential patron, William Gordon of Fyvie, he was introduced to the fourth Earl of Aberdeen (the future Prime Minister) by whom he was commissioned to advise on the planning of Haddo House policies and later to paint a series of watercolours of Aberdeenshire castles. It was on the Earl's recommendation that Giles reported successfully to Queen Victoria on the suitability of Balmoral for her prospective Highland residence.

Giles was also an energetic and regular contributor to the exhibitions of the Royal Scottish Academy. His striking view of Handa was exhibited in 1860 yet, stylistically, it appears anachronistic and should probably be associated with another aristocratic commission. In the summer of 1839 he had travelled the length and breadth of Sutherland at the request of the second Duke of Sutherland. Among the resulting watercolours was one of Handa in the remote north-western parish of Eddrachillis which the Duke had acquired a decade previously. Until 1848 this tiny island was tenanted by crofters who eked out a living by growing corn, tilling potatoes, and catching fish and seabirds in the lee of the four hundred foot cliffs. As a keen ornithologist Giles would have sought out Handa as the resort of vast colonies of migratory seabirds. Today Handa is a reserve managed by the Royal Society for the Protection of Birds.

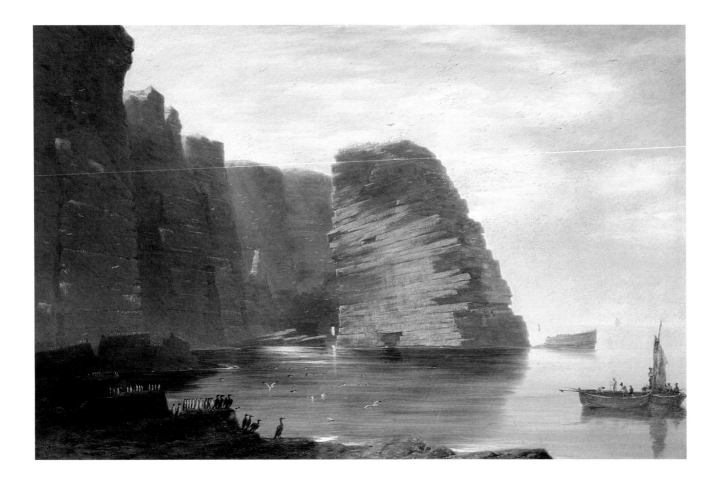

13

MACNEILL MACLEAY ARSA
c.1806–c.1878

Head of Loch Eil

Oil on canvas, 31 × 47½in (78.7 × 120.6cm)
Signed and dated *1840*
Purchased 1968

Throughout his career Macneill MacLeay's limited achievements as a landscape painter were overshadowed by those of his more versatile brother Kenneth (1802–78) who enjoyed a passing celebrity as Scotland's most accomplished miniature painter, the Raeburn of watercolour portraiture and, latterly, the creator of costume studies of Highland clansmen commissioned by Queen Victoria. Born in Oban as the sons of an impoverished militia surgeon, the MacLeays migrated to Glasgow where, in 1828, Macneill began exhibiting professionally with the Dilettanti Society. From 1829 to 1878 he contributed annually to the exhibitions of the Royal Scottish Academy in spite of a mysterious scandal which prompted his resignation from associate membership and his permanent retreat to Stirling in 1848. Ironically, when Kenneth's business as a miniaturist was bankrupted as a result of intense competition from photographers, he revived his own early interest in pure landscape in the 1860s and diversified into oil painting, almost certainly in emulation of his younger brother.

At his best MacLeay displayed a refined sensitivity to atmospheric effect and a responsiveness to the historical associations of landscape which, when combined with a romantic grandeur of conception, recall the work of his near-contemporary Horatio McCulloch. In the case of the present picture, which probably corresponds to the *View of Loch Eil looking towards Moidart* shown in Edinburgh in 1840, these associations would have been both historical and personal. Prominently posed in the foreground of the painting, three sportsmen are about to raise their glasses to a cause or persons unknown. In the summer of 1745 Prince Charles Edward Stewart had sailed from France to Moidart where he raised his standard at Glenfinnan before advancing eastwards along Loch Eil in the direction of Fort William. During the muster of the clansmen at Glen Finnan the Prince received a horse from Alexander MacDonald of Keppoch, 'the gallant Keppoch', who later fell at the Battle of Culloden. He was the maternal great-grandfather of Macneill and Kenneth MacLeay.

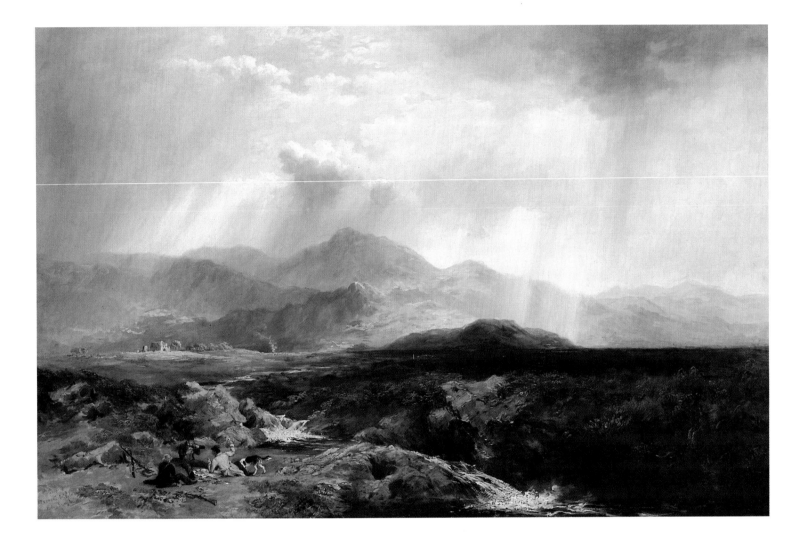

14

THOMAS MILES RICHARDSON JUNIOR RWS
1813–1890

Glencoe

Watercolour, 11¾ × 19¾in (30 × 50cm)
Purchased 1983

Richardson was the son of a well-known Newcastle upon Tyne landscape painter of the same name. Taught by his father, he started to submit works to local exhibitions from the age of fourteen, sending his first picture to London in 1832. He settled in London during the 1840s, exhibiting numerous watercolours with the Old Watercolour Society over many years. Despite their somewhat formulaic appearance, which changed little over the last forty years of the artist's career, such works remain fine testament to Richardson's tremendous skill and manipulative abilities in this most difficult of media.

Both father and son exhibited several views of the pass at Glencoe throughout their careers. The present watercolour has not been precisely dated, although it probably comes from the earlier part of the artist's career, before a series of almost entirely stock formulae started to dominate his compositions; picturesque groups of stalkers and drovers with their sheep and cattle peopling purple and brown heaths, whether in the Alps or the Highlands. Here, in contrast, the grandeur of the landscape and the sweeping clouds still dominate over the solitary shepherd and the travellers on the distant road.

It is interesting to compare this enormous work with a similar scene, on the same scale, *The Pass of Glencoe from Rannoch Moor*, which was exhibited at the summer exhibition of the Royal Society of Painters in Water-Colours in 1884 (Guildhall Art Gallery, City of London). The review in the *Art Journal* of June 1884, noted that the exhibition was 'a brave show, only marred by the infatuation which has seized its members.. to produce large works.' Certainly, by this date, Richardson's great landscape machines of Scottish and European scenery, while popular and highly prized, were attracting little critical comment from serious reviewers.

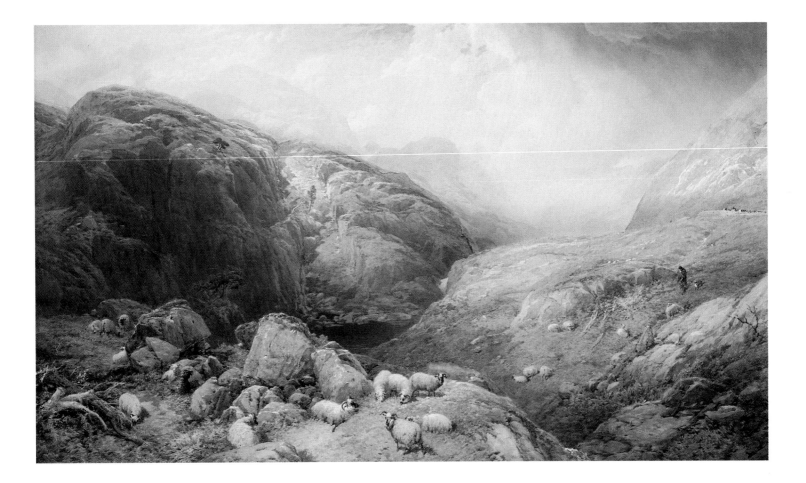

15

SAMUEL BOUGH RSA
1822–1878

Summer Evening, Cadzow

Oil on board, 13¼ × 10½in (33.7 × 26.6cm)
Signed and dated *1877*
Purchased 1979

In his important survey of Scottish painting published in 1908, Sir James Lewis Caw, the biographer and son-in-law of William McTaggart, claimed that Bough's contemporary popularity as a landscape painter far exceeded that of his close friend Alexander Fraser junior and even that of McTaggart himself. Bough's personal notoriety as a 'clever savage' with an aggressive disregard for social graces was matched by the *fougue* and vigour of his painting methods which resembled 'the capture of a fort in war'. Yet, as the son of an impoverished Carlisle shoemaker, Bough had been obliged to train himself by immersion in the works of Turner and Copley Fielding. In 1845 he obtained employment as a theatrical scene-painter, first in Manchester and then in Glasgow, thus extending the tradition of artistic interchange with Scotland which had been fostered by earlier northern artists such as T. S. Good.

From 1851 to 1854, having abandoned scene-painting in favour of pure landscape, Bough worked at Hamilton in Lanarkshire where the forest of Cadzow became one of his most productive haunts, even after his strategic move to Edinburgh in 1855. Cadzow offered the double attraction of its ancient oaks, thought to have been planted by David I in the 12th century, and a remarkable breed of wild white cattle which had been celebrated in verse by Sir Walter Scott in his *Minstrelsy of the Scottish Border*. Bough's regular painting companion at Cadzow in the 1850s, Alexander Fraser, later observed – with a commercial eye to the London art market – that Horatio McCulloch had painted 'some of his best and now most valuable subjects here' twenty years previously. Both Fraser and Bough were exhilarated by the discovery of subjects such as 'Ruysdael himself would have delighted to paint.'

On occasion, the speed of Bough's manipulation of oil paint produced effects suggestive of the watercolour medium in which he generally excelled. In this sparkling study of a summer evening at Cadzow, the ground layer shows through, adding to the overall impression of freshness and immediacy. Equally, in focusing on a specific group of picturesque oaks, Bough would have recalled, probably quite deliberately, similar choices made by McCulloch and, more memorably, by Jacob van Ruysdael. Ruysdael had also served as the model for the Barbizon group of landscape painters in the Forest of Fontainebleau.

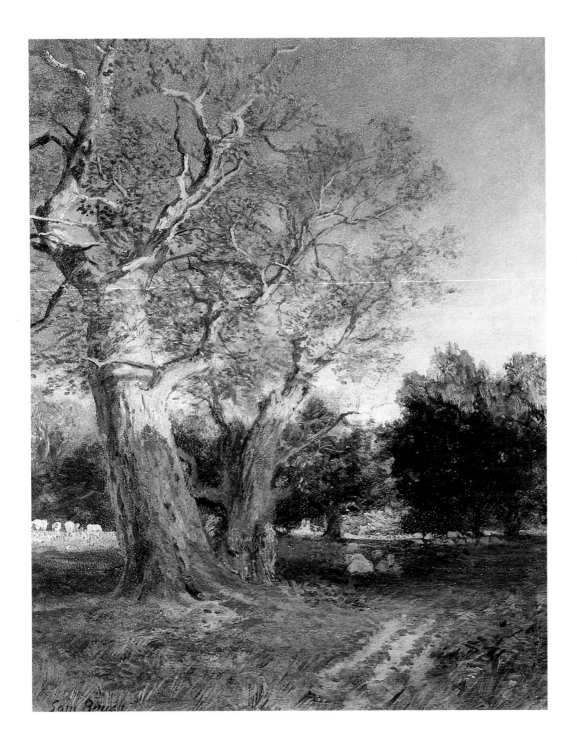

16

THOMAS FAED RA ARSA
1826–1900

The Last of the Clan

Oil on canvas, 34 × 44in (86.3 × 111.7cm)
Signed and dated *1865*
Purchased 1968

In 1851 Faed made his debut at the Royal Academy with *Auld Robin Gray*, *Cottage Piety* and *The First Step*. Encouraged by their reception, he settled permanently in London. In 1855, continuing within the Wilkie tradition, *The Mitherless Bairn* was acclaimed as the picture of the season. Meanwhile Faed was exploring the heroism and high tragedy of modern life through the topical theme of West Highland emigration to North America.

As exhibited in 1849 and 1859 respectively, *First Letter from the Emigrants* and *Sunday in the Backwoods* may have been prompted by the exodus of Faed's own McGeoch relatives. Both compositions closely resembled his rustic genre subjects in their general treatment, whereas his most ambitious emigration picture, *The Last of the Clan*, introduced an element of reportage reminiscent of W. P. Frith. The painting was authenticated in the Academy exhibition catalogue by a quotation from a (fictitious) letter to an emigrant kinsman in America, incorporating the eye-witness evidence of a member of the Clan MacAlpine from Perthshire or the Lochearnhead area. Reviewers commended Faed for his innovative approach in focusing on the relatives abandoned by the departing emigrants, both the relatively prosperous and the aged and infirm who, by implication, face the prospect of destitution. Aside from its suspect specific allusions, the painting served a more universal purpose as a lament for the passing of an entire way of life.

Later in 1865, the picture – now in Glasgow Art Gallery – was acquired by Louis Victor Flatou for 2,000 guineas, including copyright, the highest price yet received by Faed. An illiterate Prussian-Jewish émigré, Flatou practised as a chiropodist and dealer in fraudulent Raphaels and Titians before concentrating on the expanding market in modern pictures. By 1860, when he commissioned the hugely popular *The Railway Station* from Frith, with a view to engraving, Flatou had entered the league of Agnew and Gambart. From 1859 until his death in 1867 Flatou made annual speculative purchases of Faeds.

On 1 August 1865 he concluded an agreement with the leading London printsellers and publishers, Henry Graves & Co, who had engraved *The Mitherless Bairn* in 1860. In order to assist the engraver, W. H. Simmons, and safeguard his own investment, Flatou undertook to commission from Faed a reduced autograph replica – the Flemings version of the original picture. Minor discrepancies in the finished print, a virtuosic example of mixed mezzotint engraving published in 1868, are almost certainly due to Faed's corrections at proof stage.

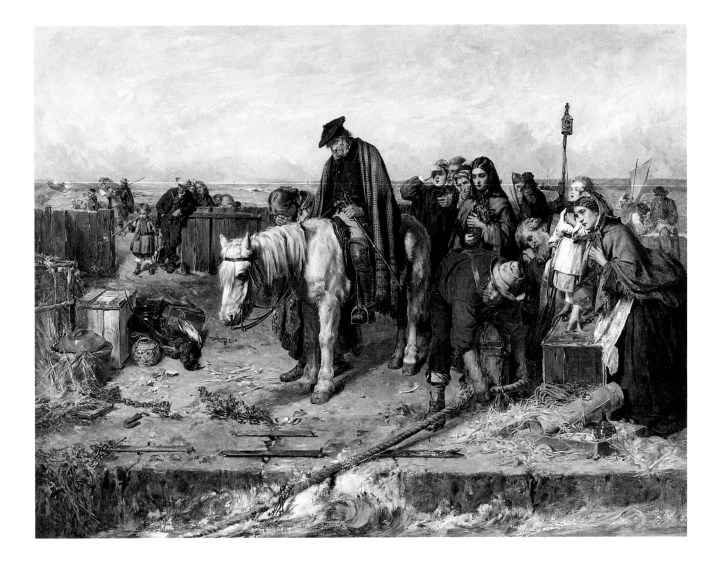

17

GEORGE PAUL CHALMERS RSA RSW
1833–1878

Reading by the Fireside

Oil on canvas, 10 × 14in (26 × 35.5cm)
Signed
Purchased 1992

The son of a Montrose sea-captain, Chalmers was un-happily apprenticed to a ships' chandler until, in 1853, he enrolled at the Trustees' Academy in Edinburgh. There he struck up a friendship with another prize-winning student of Robert Scott Lauder, William McTaggart, who was later to share some of the same Dundonian patrons. Unlike his other contemporaries Pettie, Orchardson, MacWhirter and Graham, Chalmers did not join the general exodus to London but remained committed to Edinburgh and the Royal Scottish Academy.

From the mid-1860s he was in demand both for his portraiture and for his figure compositions which, although limited in their range of subject matter, were rendered with great subtlety in the management of light and shade, and a refined, harmonious sense of colour. A highly impressionable and intuitive artist, Chalmers not infrequently jettisoned his pictures or subjected them to drastic re-working in an anguished quest for perfection in the resolution of pictorial problems. Among the canvases left unfinished in his studio at the time of his murder in 1878 was one of his most highly-prized works, *The Legend* (National Gallery of Scotland), commissioned by the Dundee collector G. B. Simpson and begun fourteen years previously.

In his less ambitious genre paintings – for all their apparent simplicity of theme and fluent modelling of form by the brush suggestive of rapid execution – Chalmers devoted no less effort to his search for intensity of expression. In this particular instance he may have been mindful of the domestic interior scenes favoured by the Hague School painter Josef Israels, whom he had met in 1870 through the Aberdonian collector John Forbes White and with whom he renewed contact in 1874 during a trip to Holland with Joseph Farquharson. Chalmers shared with Israels a preoccupation with the imaginative transmutation of well-tried genre subjects such as the present one in which he has carefully eschewed any facile degeneration into sentimental anecdotalism. Despite its modest format the picture is infused with an Rembrandtesque solemnity as though it carried the emotional weight of a meditation on old age.

A very similar treatment was adopted by Chalmers for a cabinet picture of *An Old Woman* (National Gallery of Scotland). In both cases, the figure is half-illumined from a single light source, emphasising his or her emotional and spiritual concentration. The old shepherd, like his female counterpart, is probably studying the Bible.

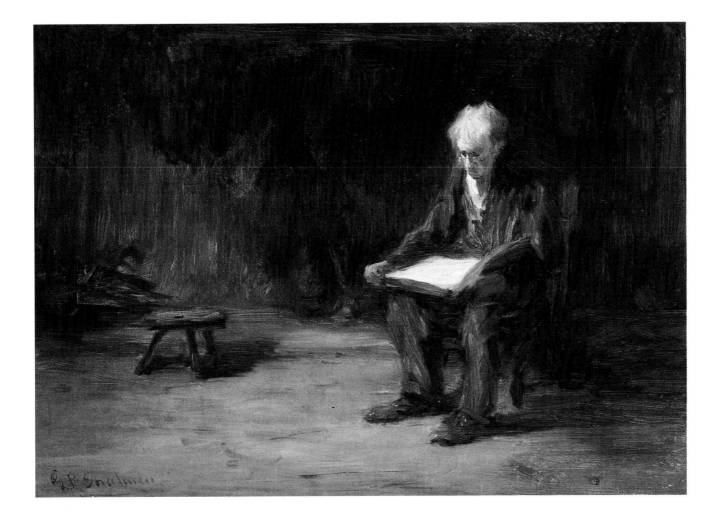

18

WILLIAM McTAGGART RSA VPRSW
1835–1910

A Day's Fishing – Morning
Oil on canvas, 18 × 24in (45.2 × 61cm)
Signed in monogram and dated *1866*
Purchased 1990

Over the summer of 1865 McTaggart returned to the Ayrshire coastal village of Fairlie where he had spent his honeymoon two years before. It was presumably at Fairlie that he painted *Morning* and its companion *Evening* (see no.19) and *The Pleasures of Hope*, all three of which were purchased by two noted Dundee collectors, William Ritchie and J. C. Bell, in advance of the Royal Scottish Academy exhibition of 1866. On this occasion, Ritchie's patronage of McTaggart was apparently prompted by his desire to emulate the commission awarded to the artist in 1863 by his own business partner, the textile manufacturer, G. B. Simpson. Both men were typical of the new generation of self-made Dundonian connoisseurs who concentrated exclusively on contemporary Scottish painting and showed a marked preference for the work of McTaggart, Orchardson, Pettie, Cameron and Chalmers, all distinguished students of Robert Scott Lauder at the Trustees' Academy in Edinburgh during the early 1850s.

In 1863 McTaggart had painted for Simpson, and the exhibition of 1864, a pair of pictures entitled *Spring* (National Gallery of Scotland) and *Autumn*, of the exact dimensions of Ritchie's pictures. As an amateur artist himself, Simpson had advised McTaggart assiduously throughout the evolution of both compositions. Ritchie, being less interventionist, merely stipulated 'a clear, truthful picture like Spring with … no hidden beauties which only a Connoisseur or artist can fathom'! Both pairs of pictures shared a thematic link – characteristic of McTaggart's painting throughout the 1860s – in the discreetly symbolic representation of childhood innocence implicitly contrasted with the complexity and sadness of adult life. In *Morning* and *Evening* the children are shown playing at fishing, presumably with little or no conception of the rigours of the seafaring life which may await them. Similarly, J. C. Bell's *The Pleasures of Hope*, with its poetic title derived from Thomas Campbell, depicted a boy sailing his toy boat and suddenly enchanted by the sight of a tall ship on the horizon.

In his own estimation, McTaggart remained first and foremost a figure painter. Throughout his life he experimented incessantly with different ways of combining figures and an independently executed landscape setting, a challenge which he may originally have taken up in response to the work of Millais. While *Spring* was remarkably innovative, *Morning* and *Evening* represented a further advance in McTaggart's progress towards a complete atmospheric unification of all the diverse elements of a composition.

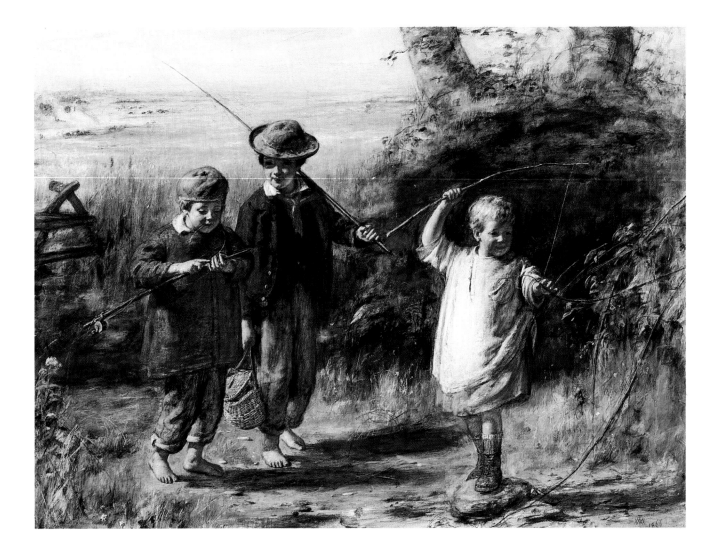

19

WILLIAM McTAGGART RSA VPRSW
1835–1910

A Day's Fishing – Evening

Oil on canvas, 18 × 24in (45.2 × 61cm)
Signed in monogram and dated *1866*
Purchased 1990

By 1866 both Ritchie and Simpson had espoused the role of commercial Maecenas with an amicable rivalry which did not exclude the occasional reciprocal exchange of pictures. As joint proprietors of the Ward Street flax-spinning mill in Dundee, they had built up a lucrative business, manufacturing canvas, sheetings and sacking. Their most intensive phase of collecting coincided with a boom period in the volatile textile industries during the 1860s. In a single decade the population of Dundee rose by one third as industrialists responded to enhanced demand resulting from the American Civil War. Like many of his peers, Ritchie advertised his increasing prosperity by building a mansion, Elmslea at Balgay, whose furnishings constituted 'a liberal education in the fine arts'.

Both business partners were evidently then among the top league of local patrons. In 1867 Simpson convened the influential committee which organised the city's first fine art exhibition on the occasion of the British Association meeting in Dundee. This exhibition was conceived as an impressive manifestation of Dundee's commercial and cultural vitality and the interdependence between the new industrial wealth and the growth of artistic patronage. Simpson's most active coadjutors, who liaised with con-

temporary artists in Glasgow and Edinburgh, were mainly fellow collectors of comparable stature – Ritchie, J. C. Bell and J. G. Orchar. To this retrospective survey of the finest achievements in Scottish painting Ritchie submitted *Morning* and *Evening* and an original sketch for *The Murmur of the Shell* (he had lent the finished picture to the Royal Scottish Academy exhibition). His partner's more numerous contributions included *Spring*, *Autumn* and *Enoch Arden* by McTaggart and *The Spell* by Fettes Douglas whose work particularly appealed to Simpson.

For almost a decade Ritchie, Simpson and J. C. Bell featured prominently among the owners of McTaggarts lent to the Academy's exhibitions. In 1871 Ritchie made his last significant purchase *Adrift*. Thereafter, J. G. Orchar, who ultimately owned twenty two McTaggarts, took pride of place among the artist's Dundonian friends and patrons. The implied preference of Ritchie and Simpson for the early works of McTaggart was probably determined as much by economics as by taste. Following some disastrous overseas financial investments, the co-partnership was dissolved in 1877. Ritchie's collection, including *Morning and Evening*, was dispersed by auction at Dowell's of Edinburgh in 1885.

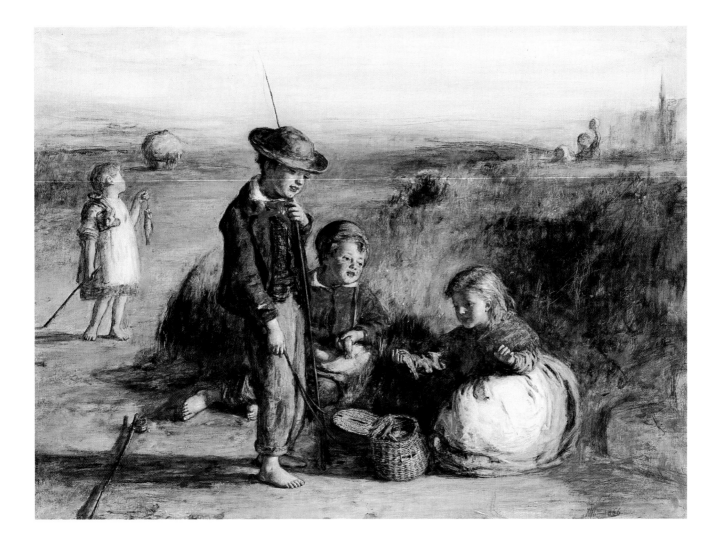

20

WILLIAM McTAGGART RSA VPRSW
1835–1910

The Village, Whitehouse

Oil on canvas, 46 × 70in (116.8 × 177.8cm)
Signed and dated *1875*
Purchased 1989

From 1866, when he made his Royal Academy debut with G. B. Simpson's picture *Enoch Arden*, McTaggart visited London annually in order to examine the summer exhibition and to renew contact with John Pettie and the other voluntary exiles from the Scott Lauder coterie. After 1875 McTaggart ceased to exhibit in London, preferring to be 'first in my own country' rather than 'second in any other'. His final contribution was *The Village, Whitehouse*. It was launched with a self-consciously literary but aptly descriptive title, *Twas Autumn, and Sunshine arose on the Way*, from Thomas Campbell's poem *The Soldier's Return*.

James Caw, McTaggart's son-in-law and authoritative biographer, assigned the genesis of the picture – provisionally – to a summer sketching tour of northern Kintyre in 1871, the little clachan of Whitehouse being located near West Loch Tarbert. However, the idea for the picture conceivably originated as early as 1864. G. B. Simpson compiled an annotated dossier of his own correspondence with Chalmers, interleaved with photographs of most of the paintings under discussion. Over the winter of 1864/5 Chalmers was writing enthusiastically of a 'Large Village Study', as yet without figures, on which McTaggart was engaged concurrently with *The Press Gang*. In Simpson's

opinion, Chalmers was referring to the painting which eventually evolved as *The Village, Whitehouse*.

McTaggart evidently set great store by this picture. Subsequently, it was selected as a masterpiece for the Scottish National Exhibition of 1908 and the McTaggart Centenary Exhibition of 1935 and acclaimed by the Scottish Press as deserving of inclusion in a major public collection. In 1875, however, after being by-passed by the London critics, the painting was secured by a Glasgow dealer who maintained to an incensed McTaggart that its relative lack of finish required revision in order to guarantee a sale. McTaggart habitually reacted to such uncomprehending adverse criticism with a steadfast refusal to compromise his artistic intentions. He retained the picture for a year and returned it unaltered.

By December 1876 it had been purchased by John Ure, a prominent Glasgow business man and future Lord Provost. Although residing in the artistically oriented community of Helensburgh, Ure was widely known for his reformative promotion of public health rather than for his connoisseurship! Evidently he subscribed to one responsive critic's appreciation of the painting as 'one glorious phrase of sunlight, its each articulation pictorially *joyous*'.

21

JOSEPH FARQUHARSON OF FINZEAN RA
1846–1935

Feluccas on the Nile

Oil on canvas laid on panel, 6½ × 18¾in (16.4 × 34.9cm)
Purchased 1982

The youngest son of the Laird of Finzean on Deeside, Farquharson received his first instruction from Peter Graham, a family friend who had been one of Robert Scott Lauder's most promising pupils at the Trustees' Academy in Edinburgh. Both Graham and Farquharson, a decade later, were to enjoy prosperous careers as London-based painters of Highland landscape, each extending his distinctive reputation by collaborating in the commercial publication of engravings. In 1874 Farquharson travelled to the Netherlands and Belgium with G. P. Chalmers in quest of Rubens, Rembrandt and Josef Israels of the Hague School, then much admired by Scottish painters and collectors. After establishing a London studio, Farquharson spent several winters in Paris studying with Carolus-Duran, the friend of Manet and teacher of Sargent with whom Farquharson himself formed a close friendship.

Farquharson had long been converted to *plein air* landscape painting, an enthusiasm which must have been revitalised by his recent exposure to the early Impressionist exhibitions. The rigours of the north-eastern Scottish climate, however, demanded particular resourcefulness. For his periodic excursions to Deeside Farquharson designed a mobile painting hut, complete with stove and capable of withstanding near-blizzard conditions. This hut literally became the foundation of the popular success of 'Frozen Mutton Farquharson' whose technical virtuosity as a snow painter was, in Sickert's estimation, unrivalled by any of his contemporaries including Courbet.

During the late 1880s and early 1890s Farquharson experimented with Orientalist painting stimulated by a tour of Egypt in 1885. He revealed himself to be an excellent colourist. On the opening of the Suez Canal in 1869, Egypt had experienced the growth of mass tourism, facilitated by Thomas Cook's highly planned tours of the Nile. The alternative tourists, the artist travellers who followed in the wake of the draughtsmen attached to the Napoleonic campaign of 1798, had included several Scots – most notably David Roberts who, in the 1840s, had published with resounding success his sketches of Egypt and the Holy Land. Farquharson's refined and atmospheric sketch of feluccas is one of several oil studies, probably executed direct from nature, for the finished picture *He Drove them Wandering o'er the Sandy Way*. This evocative subject picture of an Egyptian shepherd and his flocks against a background of the Nile was shown at the Royal Academy in 1891. It may have been intended as a contrast to Farquharson's more usual Highland repertoire.

22

SIR DAVID MURRAY RA HRSA LLD
1849–1933

Woodsman and Horse in an Autumn Landscape

Oil on board, 5½ × 8in (14 × 20.3cm)
Signed and dated *1886*
Purchased 1979

For eleven years Murray engaged in business in his native Glasgow while studying part-time at Glasgow School of Art under the watercolourist, Robert Greenlees, whose most progressive students would later include James Paterson, E. A. Walton, George Henry and James McLachlan Nairn. In contradistinction to the younger generation, Murray began to develop under Greenlees's direction a meticulous realism in the representation of landscape which was to earn him both popular acclaim and ultimately, in 1918, the accolade of a knighthood. From the early 1870s, having resolved on an artistic career, he began to exhibit at the Royal Scottish Academy and in 1875 made his debut at the Royal Academy in London. In 1882 Murray settled in London, a move in which he may have been encouraged by the success which had attended two other Scottish expatriate landscape painters, some ten years his senior, John MacWhirter and Peter Graham.

Murray's later landscapes, painted in a variety of southern locations from Devonshire and Hampshire to Kent and the South Downs, were mostly highly-keyed and expressive of the grandeur and 'splendid impassiveness' of nature. Yet he was also known for his intrepidity in 'habitually attacking six-foot canvases in open air.' This passionate dedication to direct painting from nature – whether in oils or in watercolour in which he showed equal facility – cannot have been unrelated to his admiration for Constable and Corot who excelled in the art of the landscape sketch. While still based in Glasgow, Murray may have encountered the work of Corot among the first stock of the aspiring dealer, Alexander Reid. Other opportunities would have been afforded by Murray's periodic excursions to northern France. This unpretentious little picture is probably a *plein air* sketch executed during one such painting excursion to Picardy which he undertook in 1886.

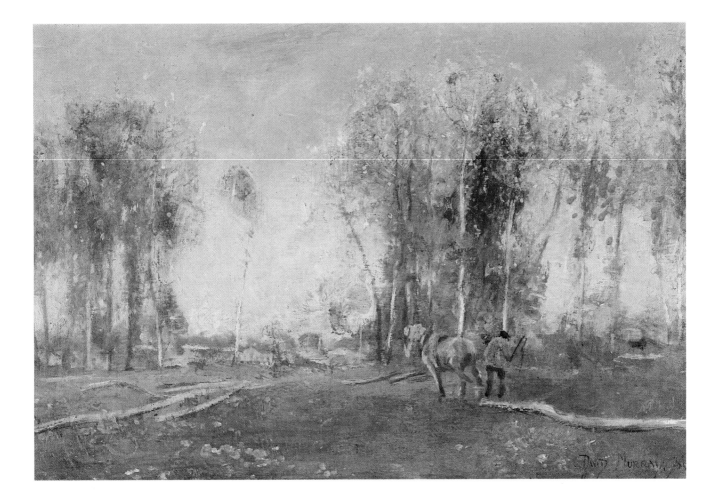

23

JOHN ROBERTSON REID RBA ROI RI
1851–1926

Leaving School

Oil on canvas, 14 × 20in (35.6 × 50.8cm)
Signed and indistinctly dated *1898*
Purchased 1993

In his disenchantment with his apprenticeship to an Edinburgh house-painter, Reid contemplated going to sea before beginning part-time study at the Trustees' Academy or School of Design. He also attended Life Classes at the Royal Scottish Academy where the inspirational teaching of George Paul Chalmers and William McTaggart in the early 1870s was to exercise a lasting influence on his own evolution as a painter of landscape and rustic genre. A visit to Surrey in 1874 confirmed Reid's growing interest in *plein air* landscape painting in conjunction with an anecdotal and not infrequently sentimental exploration of rural life. Following the precedent set by the exodus of Orchardson, Pettie, MacWhirter and Graham to London during the previous decade, he migrated first to Sussex and then to Hampstead in 1879. It was in London that he encountered Pettie's pupil, James Guthrie, whose own rather different conversion to ruralist motifs in the 1880s was probably partially stimulated by Reid's example.

In *Leaving School,* in which the influence of McTaggart is still discernible, Reid offers a fresh and luminous re-interpretation of a pictorial tradition which had proved to be particularly fertile in 19th-century Scottish genre painting. Between 1832 and 1846 Sir George Harvey had exhibited at the Royal Scottish Academy three varied compositions on the popular subject of the village school. Of these, the latest and most ambitious was *A Schule Skailin'* (National Gallery of Scotland) which depicted the unruly dispersal of the pupils at the close of the day. In 1851, in continuation of this same vernacular vein, *The Visit of the Patron and Patroness to the Village School* by Thomas Faed (McManus Galleries, Dundee) had revealed its common thematic origins in *The Village School* of Sir David Wilkie (see no. 3). Here, Reid has translated an essentially Scottish theme into a southern context and an outdoor setting in accordance with his own immediate preoccupations.

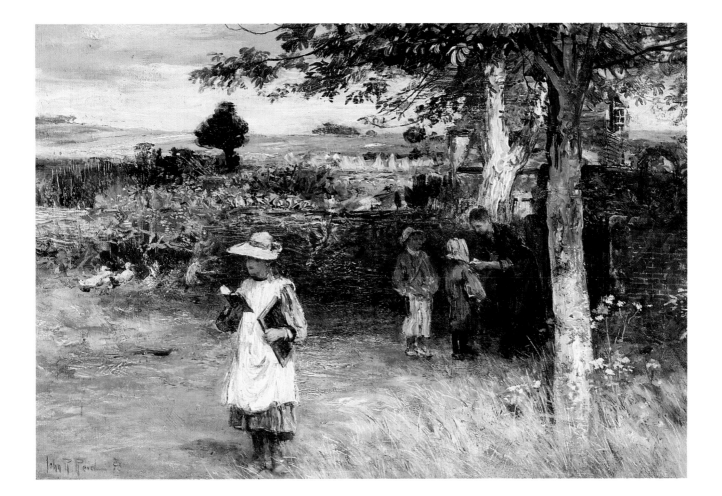

24

JOHN WATSON NICOL ROI
1856–1926

Lochaber No More

Oil on canvas, 43 × 33in (109.2 × 83.8cm)
Signed and dated *1883*
Purchased 1990

Nowadays, Nicol's reputation effectively rests on this single picture, one of the most enduringly evocative images commemorating Highland emigration. Quite apart from its inherent topicality, Nicol's belated exploration of this theme cannot have been unrelated to the precedent set by his father, the 'painter-in-ordinary to the Irish peasant'. Erskine Nicol's experience of Dublin during the 1840s immediately before the mass famine emigrations had provided the raw material for an extended series of Irish subject pictures. The *Irish Emigrant landing at Liverpool* (National Gallery of Scotland) is a monumental example of this genre, painted in 1871 with Nicol's usual touch of pawky humour.

The younger Nicol's masterpiece was purchased from the Royal Academy exhibition of 1883 by a London collector. In 1884 the *Art Journal* congratulated Nicol on his portrayal of 'the tragedy of the Highland shepherd's life' and commented on his calculated deployment of telling details, such as the now-redundant crook, the displaced and mournful collie, the essential household utensils and the pitiably small bundle of personal possessions – a device for which Nicol was clearly much indebted to Thomas Faed. The extreme simplicity of the composition, focused on a theatrical *tableau vivant* of two figures, is similarly condu-

cive to a generalised interpretation of the picture as a summation of the collective experience of an entire century. In spite of its plausibly West Highland context, the picture is probably intended to call to mind the most celebrated archetypal image of earlier 19th-century emigration, Ford Madox Brown's *The Last of England*, which had been exhibited in Liverpool in 1856.

The production of Nicol's picture coincided with the so-called 'Crofters' Wars' on Skye and the appointment of the Napier Commission to investigate questions of eviction, land ownership and emigration. The north-west Highland region of Lochaber had indeed witnessed significant emigration to North America, both voluntary and enforced, for almost a century. It was also the territory of the Camerons of Lochiel, staunch supporters of the Prince during the Forty-Five Rising. Moreover *Lochaber No More* was both the title of a pibroch lament much favoured by departing Scottish emigrants, and the opening line of a song by Allan Ramsay. This song had first been published in 1727 and referred to the earlier history of the Camerons of Lochiel. Nicol's choice of such an allusive title, capable of encompassing a multiplicity of meanings, must reflect a considered decision to be guided by pathos rather than polemics.

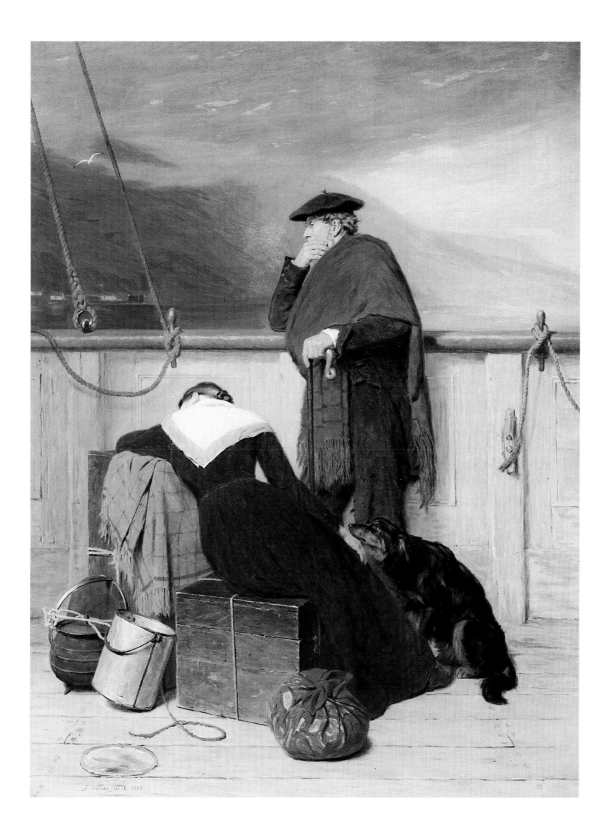

25

JAMES PATERSON RSA PRSW RWS
1854–1932

Winter Sunshine, Moniaive

Oil on canvas, 24 × 16in (61 × 40.8cm)
Signed, inscribed and dated *1889*
Purchased 1982

From the outset Paterson was recognised as being one of the leading figures of the Glasgow School, both for his achievements as a landscape painter and as the chief promoter of the Boys' literary organ, the short-lived *Scottish Art Review* which was launched in 1888. As the son of a prosperous cotton and muslin manufacturer, Paterson was originally discouraged from pursuing a full-time artistic career. In 1877, however, he secured an allowance in order to study with Jacquesson de la Chevreuse, a former pupil of Ingres, and Jean-Paul Laurens. The first of the Boys to study in France, Paterson made an annual pilgrimage to the Paris ateliers until 1883.

His closest associate in Glasgow and regular painting companion for summer excursions to Fife and north-east Scotland was W. Y. Macgregor (see no.26). From 1879 Paterson began to explore the alternative attractions of the Dumfriesshire village of Moniaive and the nearby Glencairn valley. Following his marriage in 1884, he settled in Moniaive which became his permanent base until his decisive move to Edinburgh in 1897. Unlike most of the Boys, he was primarily a landscape painter for whom figures were of incidental significance only. Far from being restrictive, his enduring commitment to Moniaive reflected his conviction that a landscape painter should not 'flirt with a new neighbour each remaining summer but … marry metaphysically some well-chosen space'. By avoiding intrinsically picturesque subject matter and concentrating on a single locality throughout the changing seasons, Paterson was able to realise his particular capacity to abstract the quintessential forms of the landscape and to invest his compositions with a special feeling of time and place.

The countryside around Moniaive inspired some of Paterson's finest pictures including *Autumn in Glencairn* (National Gallery of Scotland) which was acknowledged to be his most important and expressive Dumfriesshire landscape when exhibited at the Glasgow Institute in 1888. Many of his other large-scale Moniaive landscapes were sold in Europe from the exhibitions to which the Boys were invited to contribute during the 1890s (Paterson himself was awarded a gold medal on the occasion of the Boys' outstanding success in Munich in 1890). The quality of this smaller work evidently occasioned its purchase by Craibe Angus of Glasgow, one of a select group of cosmopolitan Scottish art dealers who also promoted a wider public appreciation of the Barbizon and Hague School painters.

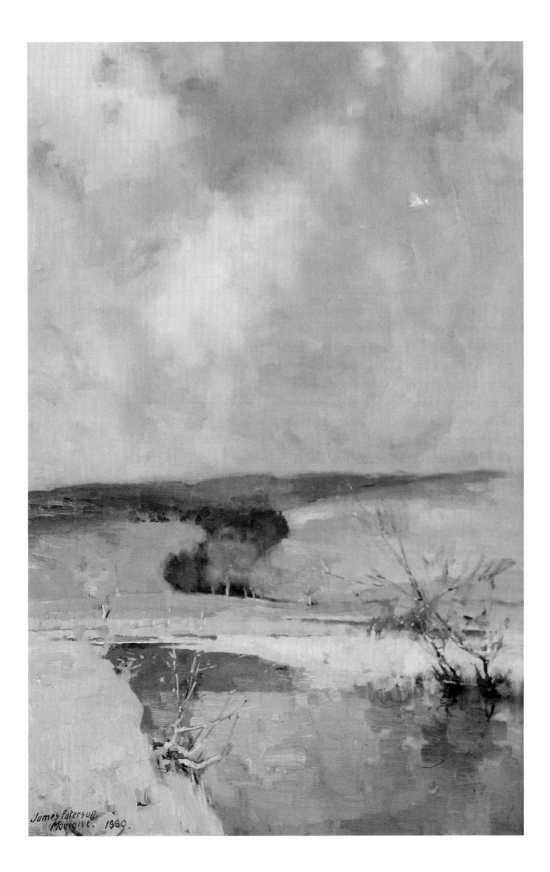

26

WILLIAM YORK MACGREGOR RSA RSW
1855–1923

Near St Andrews

Oil on canvas, 19¼ × 24in (48.9 × 61cm)
Signed
Purchased 1982

Macgregor's choice of profession was at first vehemently opposed by his father, a partner in the Clydeside shipbuilding firm of Tod and Macgregor which had pioneered the production of iron sea-going steamships. From Glasgow School of Art he proceeded to the Slade to study under the influential painter-etcher Alphonse Legros. A friend of Degas, Fantin-Latour and Whistler, Legros had settled in London in 1863, but maintained strong links with the French Realist painters of peasant life. Over the summer of 1877 or 1878 Macgregor renewed contact with his former Glasgow schoolmate James Paterson during an interlude in Paterson's own studies in Paris. That summer witnessed the first of several painting excursions to St Andrews and the Fife coast, Stonehaven and Nairn, and the effective beginning of a definable movement which from 1890 was to become known as the 'Glasgow School'.

Both Paterson and Macgregor were some five to seven years older than the majority of the 'Glasgow Boys' including Guthrie, Walton and Crawhall who met at the St Mungo Art Club in the winter of 1878. This loose-knit group was united in seeking to challenge the prevailing aesthetics of and public patronage for 'the Gluepots' or purveyors of self-consciously picturesque and sentimen-tally anecdotal pictures characterised by a partiality for heavy, syrupy oil or megilp. The Boys' growing sense of collective purpose was fostered by regular meetings at Macgregor's studio at 134 Bath Street in Glasgow where they congregated over the winters of 1883 and 1884 for discussion and instruction.

Macgregor's masterpiece *The Vegetable Stall* (National Gallery of Scotland) was painted in 1884 in the Fife fishing village of Crail. His vigorous and painterly, yet tautly-structured treatment of realistic, un-picturesque subject matter epitomised the ideals of the Boys during the critical opening years of the decade. Macgregor's influence on the younger painters was fundamental until in 1886 his suscep-tibility to asthma forced him to seek a retreat, firstly at Bridge of Allan and then in South Africa. By the time of his return to Scotland in 1890, he had begun to distance him-self from the objectives of the 'Frenchy School' including his former Glasgow associates. With its simple motif and intense colour, this undated little landscape probably be-longs to the second phase of Macgregor's career when he developed a brilliant colourism, anticipating later trends in Scottish painting and, in particular, the work of the Scot-tish Colourist, F. C. B. Cadell.

27

ARTHUR MELVILLE ARSA RWS RSW
1855-1904

Pangbourne

Watercolour, 10 × 14¾in (25.4 × 37.47cm)
Signed and inscribed *Pangbourne 1889*
Purchased 1970

Melville was born in Angus, although his family moved to East Lothian while he was still a boy. At the age of fifteen he was apprenticed to the village grocer. Determined to pursue his interest in drawing, Melville studied at evening classes in Edinburgh. In 1875, Melville exhibited and sold his first picture at the RSA. His parents finally relented in their opposition to his chosen career and Melville went to study, first in the Edinburgh studio of James Campbell Noble and then, in 1878, in Paris. Soon after Melville arrived in France he began to work at Grez-sur-Loing, settling there in the spring of 1879. It was during this period that he developed the 'blottesque' watercolour manner which became a hallmark of his greatest works of the 1880s and 1890s.

Melville returned briefly to Edinburgh in 1880. His French works sold well and with the proceeds he was able to fund a journey to the Middle East later in the year. After leaving Cairo, early in 1882, Melville travelled by sea to India before journeying home overland through Turkey and eastern Europe.

In the period after Melville's return from the Middle East, having settled in Scotland once more, he began to associate with his young Glasgow contemporaries, particularly Joseph Crawhall and James Guthrie. The winter of 1883 to 1884 was spent at Cockburnspath and visits to Orkney and to France were made with Guthrie in 1885 and 1886 respectively. Recognition for Melville's work was slow to develop in Scotland. In 1888, however he was elected an Associate of the Royal Society of Painters in Watercolours. The following year, 1889, the date of the watercolour, *Pangbourne*, he moved to London. Like many of Melville's watercolours of the period, *Pangbourne* reflects further development in the artist's technique after his return from the Middle East. Deprived of the dazzling light which had suffused even the darkest corners in his Arabian compositions with colour, Melville's great watercolours of the mid-1880s, such as those of St. Magnus Cathedral in Kirkwall, had gained a luminosity which even the dullest Orcadian dusk could not extinguish. Here, in this sunny English landscape, while the dusty road and bleached sky echo those seen in the artist's Middle Eastern views, the colours are less intense and the composition and topography much closer to the manner of his Glasgow contemporaries.

"Langbourne."

Arthur Melville.

1887.

28

ARTHUR MELVILLE ARSA RWS RSW
1855–1904

Orange Market, Saragossa

Watercolour, 23 × 30in (58.4 × 76.2cm)
Signed and dated '92
Purchased 1994

From his first appearance at exhibitions of the Royal Society of Painters in Watercolours, reviewers had noted the extraordinary contradictions which run through Melville's watercolours of the late 1880s and early 1890s. While works such as *Pangbourne* put him in the critics' 'so-called realist division', a strong decorative streak, heavily influenced by Whistler, is also apparent in many watercolours. Again, as in the early 1880s, a drive towards abstraction and the use of intense colours came from foreign travels. Melville visited Spain every year between 1890 and 1893 and again in 1899.

The magnificent *Orange Market, Saragossa* dates from 1892. In marked contrast to the view of *Pangbourne,* here the decorative elements in Melville's work dominate over any inclination towards the topographical tradition seen in the view of the sleepy English village; piled oranges reflected in the deep blue water; the planes of quay, walls and steps rendered a series of almost abstract shadows and highlights. The studies for the watercolour were done in the company of the young Frank Brangwyn who accompanied Melville to Spain in 1892. Brangwyn's journal of the trip was published in the first two volumes of *The Studio.* The city of Saragossa itself turned out to be a great disappointment to the two men who hired a barge for several days to travel on the canal to Caillon. It was on their return that the watercolour was painted.

29

SIR JOHN LAVERY RA RSA RHA
1856–1941

Bridge at Hesterworth, Shropshire

Oil on canvas, 12 × 30in (30.5 × 76.2cm)
Signed, inscribed and dated *December 1884*
Purchased 1975

Lavery's career began inauspiciously. He was to become a leading member of the Glasgow School and latterly an international society portrait painter catering to the Hollywood stars of the 1930s. The son of a failed wine merchant from Belfast, he was orphaned at the age of three and raised by a distant relative in Ayrshire. Having run away to Glasgow, he was engaged by a portrait photographer as a miniature painter over photographs on ivory. When Lavery's studio was gutted by fire, the insurance unexpectedly enabled him to realise a crucial ambition. From Heatherley's Art School in London, he gravitated to Paris and the Académie Julian in whose liberal atmosphere radical ideas were readily generated.

At the Paris Salon of 1882 Lavery received a double accolade. His student work, *Les Deux Pêcheurs*, was hung on the line beside Manet's *Bar aux Folies-Bergère* and purchased by a French sculptor. Over the summer of 1883 he followed his fellow-students Stott of Oldham and O'Meara to the village of Grez-sur-Loing where Corot had often stayed – a predictable choice for a painter from Glasgow, where the landscapes of the Barbizon School had been appreciated far earlier than in the rest of Britain.

Lavery might well have settled in Paris as the epicentre of avant-garde developments in painting, but for his lack of fluency in French, a pre-requisite of admission to the Ecole des Beaux-Arts. After returning to Grez for the first nine months of 1884, he opted for a career in Glasgow.

At Hesterworth Lavery seems to have experimented with a motif recalling, however indirectly, the famous bridge at Grez, which, by his own admission, he had painted at least ten times and which had inspired his first important picture in 1883. Lavery's near-contemporary, D. S. MacColl, ascribed to the Académie Julian the dissemination of a method of painting derived from Bastien-Lepage. In its extreme manifestations, this technique was recognisable 'by a swaggering way of painting across forms, by a choppy rendering of planes and by attention to values at the expense of colour'. In his view of Hesterworth, Lavery's brushwork, although undoubtedly revelatory of his French training, is modulated in order to create a sense of spatial depth without sacrificing pictorial unity. Paradoxically, every element of this naturalistic composition is skilfully contrived so as to enhance the prevailing impression of stability and rural tranquillity.

30

ROBERT NOBLE RSA
1857–1917

Queen Mary's Bath House, Holyrood

Oil on millboard, 5½ × 9¼in (14 × 23.4cm)
Signed and dated *1880*
Purchased 1968

This refined study of the contrasting effects of light in defining and dissolving architectural form belongs to the earliest experimental phase of Noble's career. In 1879 he graduated from the studio of his older cousin, James Campbell Noble, a successful painter of landscape and rustic genre, to the Life Schools of the Royal Scottish Academy. Following a further period of technical development in Paris under Carolus-Duran, Robert Noble turned decisively to landscape painting. Finally, in 1889, he moved to the Haddingtonshire village of East Linton, a locality with which William Darling McKay and Robert McGregor were also closely identified.

By the late 1870s Noble had established an independent studio at Abbeyhill in close proximity to Holyrood Palace. The intimate scale and conception of this picture is typical of an exploratory work painted for private enjoyment and instruction, yet it was probably related to a series of studies of the old closes of the Canongate which Noble exhibited at the Academy in 1879 and 1880. The idea for this series may have been stimulated by a contemporary publication whose objectives were both aesthetic and documentary. In 1879 the Society of Antiquaries of Scotland produced a memorial volume of the drawings of Old Edinburgh by James Drummond, curator of the National Gallery of Scotland and a history painter of romantic antiquarian inclinations. Many of his drawings had been executed in response to the immediate threat of demolition arising from civic improvements in the Old Town during the 1850s.

The late 16th-century garden pavilion, commonly known as the Bath House, was originally situated within the Privy Garden attached to Holyrood Palace. From the 1850s, it was left stranded as an architectural curiosity when the garden was bisected by a new carriage-drive. Popular tradition associated this pavilion with Mary, Queen of Scots and her personal beauty treatment by immersion in white wine. This tradition was revitalised by the discovery in the late 18th century of an ornate dagger hidden in the roof. Naturally, this was assumed to have been discarded by one of the assassins of David Rizzio as they fled through the Privy Garden on 9 March 1566!

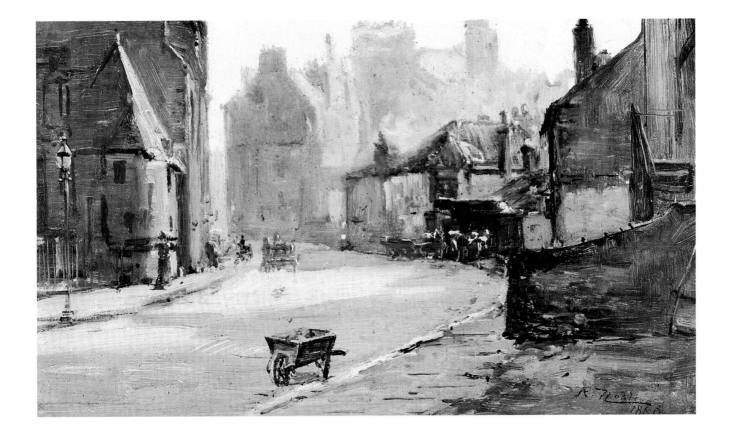

31

GEORGE HENRY RA RSA RSW
1858–1943

Girl Reading

Pastel on grey paper, 24 × 27½in (60.9 × 69.8cm)
Signed and dated *1896*
Purchased 1978

Henry was born in Ayrshire. One of the longest surviving members of the Glasgow Boys, he was always reluctant to discuss his early life, and little is known of his background. It is probable that Henry first encountered the emerging group of Glasgow-trained painters in 1880, through the St Mungo Society, a club for young painters who were not yet admitted to the Glasgow Art Club. During the early 1880s, Henry's closest associates among the Glasgow Boys began to spend summers at Cockburnspath in Berwickshire. He joined E. A. Walton, James Guthrie and Joseph Crawhall there for the first time in 1883.

It was possibly in Guthrie's company that Henry visited Kirkcudbright in 1885 and met the young artist with whom he was to develop a close friendship over the next decade, Edward Atkinson Hornel. For several years, summers were divided between Berwickshire and Galloway, although it was increasingly in the West that the two friends based themselves. The painting of both men altered subtly during the last years of the 1880s: Henry's had long showed a decorative tendency, increasingly distant from the kailyard realism of Guthrie and Walton. In 1889, Henry exhibited what is undoubtedly his masterpiece, *Galloway Landscape* (Glasgow Art Gallery) at the Glasgow Institute. The picture marked the start of even greater decorative tendencies in Henry's painting. Paintings such as *The Druids* of 1890 and *The Star in the East* of 1891 (both Glasgow Art Gallery), painted in collaboration with Hornel, take these developments away from realism still further.

Girl Reading, of 1896, dates from shortly after Henry returned from his lengthy visit, in Hornel's company, to Japan. Although many artists had made much, during the last quarter of the century, of Japanese use of line and design, learned at second hand, this direct experience of the country, for more than a year from the middle of 1893, was profoundly influential on both men. Much of Henry's work from this period is on paper, both in watercolour and, as here, in pastel, a medium which had recently become particularly popular. Although done after his return from the East, Henry has made use of the decorative possibilities of Oriental fashions. Almost Whistlerian in its economy, the drawing centres as much attention on the blue hair decoration and the almost golden pages of the book as it does on the girl herself. An abstract band of yellow to the left of the girl turns even Henry's signature into a central and decorative feature of the composition.

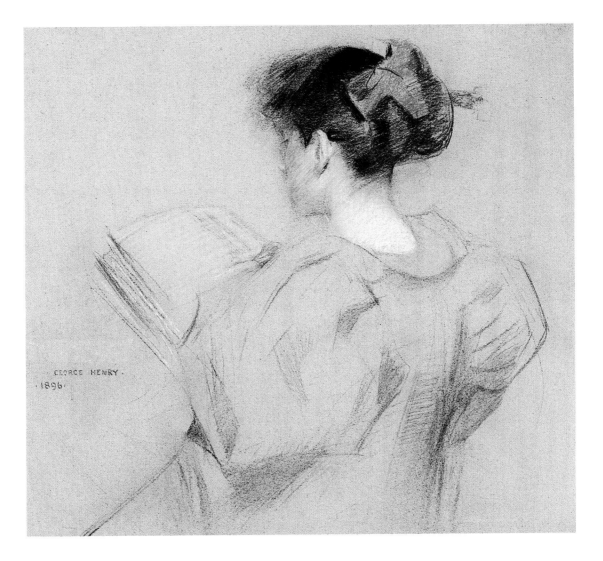

32

JAMES McLACHLAN NAIRN
1859–1904

View of Corrie on Arran

Oil on canvas, 12 × 18in (30.5 × 45.7cm)
Signed and dated *1887*
Purchased 1994

Born at Campsie Junction near Glasgow, Nairn attended classes at Glasgow School of Art and W. Y. MacGregor's Bath Street Studio while officially training as an architect. In 1882, with his close friend George Henry, he founded the Palette Club as an alternative exhibition venue, but in 1883 he secured election to the prestigious Glasgow Art Club. That summer, while Guthrie, Walton and Crawhall were painting together at Cockburnspath, Nairn apparently joined forces with Henry at the nearby village of Eyemouth. The importance of their creative interchange may be gauged from the stylistic influence of Henry on a series of Arran landscapes painted by Nairn over the summer of 1886.

The relative accessibility, rich colours and pronounced contrasts of Arran had already attracted Scottish artists as diverse as Dyce, Chalmers, Herdman and Noel Paton. From 1911 E. A. Taylor and Jessie M. King would base their annual summer schools near the Port of Corrie which served both the coal smacks and the large ferries from Gourock and Ardrossan. Nairn's Corrie landscape must have been completed within months of *Twixt Sun and Moon – Auchenhew,* first exhibited at the Glasgow Institute

of the Fine Arts in 1887. In both pictures the solitary figures are immobilised as though entranced, like the artist himself, by the elusive and infinitely variable quality of island light. In *Auchenhew* the all-enveloping serenity of twilight evokes a mood which is almost mystical. Here, cottages, boats and vegetation are simplified and recreated by the irradiation of intense sunlight. This quasi-visionary element in Nairn's response to landscape is combined with a strong commitment to pattern-making in which each pictorial motif is integrated within the total harmony of the design.

In 1888, at the instigation of Fra Newbery, Nairn and the majority of the Glasgow Boys received commissions for decorative murals for the Glasgow International Exhibition. His brief association with the group had coincided with a critical phase in their aesthetic development. The following September, however, he set sail for New Zealand, where his sister's family had settled, on what was intended to be an extended, recuperative visit. He never returned to Scotland. When he died prematurely in Wellington in 1904, Nairn was mourned as the colony's foremost landscape and portrait painter.

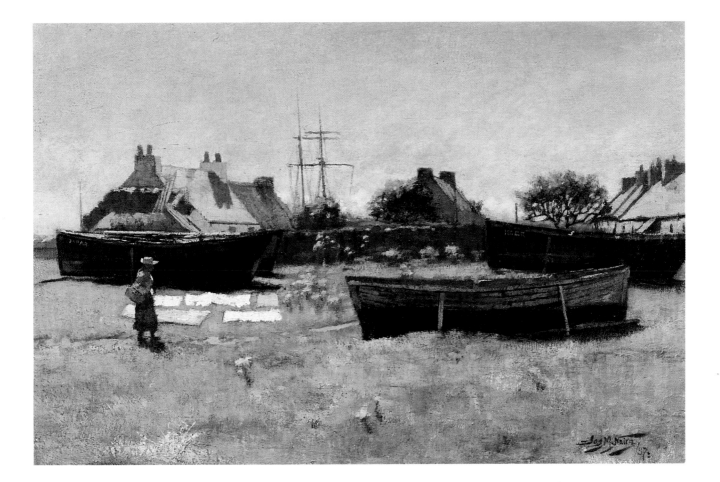

33

EDWARD ARTHUR WALTON RSA PRSW
1860–1922

Back Wynd, Ceres

Oil on canvas, 31 × 25in (78.7 × 63.5cm)
Signed
Purchased 1982

The son of an amateur painter, Jackson Walton of Glanderston House in Renfrewshire and the older brother of the interior designer, George Walton, E. A. Walton was raised in comfortable circumstances which facilitated his studies at the Düsseldorf Kunstakademie. Following further studies at Glasgow School of Art, Walton made his debut as a landscape painter at the Glasgow Institute and secured election to the Art Club in 1878. Over that winter his encounter with James Guthrie at the St Mungo Art Club began one of the most enduringly creative friendships among the Glasgow Boys. This association was soon extended to include Joseph Crawhall, whose sister had recently married into the Walton family.

In 1880 the trio painted together at Roseneath on the Gare Loch; in 1881 at Brig o' Turk in the Trossachs (where they were joined by George Henry); and in 1882 at Crowland in Lincolnshire. Over the summer of 1883 Walton and Guthrie discovered Cockburnspath in Berwickshire, which was to become their seasonal headquarters and equivalent of Barbizon. Having extended his search for fresh painting localities to the softer countryside of Worcestershire and Somerset, Walton returned to Scotland in 1886.

At his Cambuskenneth studio, the Boys reconvened and thrashed out the largely Whistlerian ideas which were to assume literary form in the *Scottish Art Review*.

This undated view of the picturesque Fife village of Ceres probably belongs to this exploratory and markedly experimental period of Walton's career. As late as 1920 he showed at the Royal Scottish Academy another view of the village which was thus practically contemporary with the landscapes painted in the same locality by the Scottish Colourist, George Leslie Hunter (see no.53). In this instance, Walton's vision of Ceres is so unmistakably French in character as to be indicative of a much earlier origin. His choice of a low-keyed tonal range and his handling of the striking central motif of the tree in combination with other motifs such as the horse and rider and the farm outbuildings all reveal his familiarity with the late works of Corot. Corots had been extensively imported into Britain from the 1870s. In 1880 several were exhibited by the Glasgow dealer Alexander Reid, a friend and promoter of Walton, and in 1888 R. A. M. Stevenson contributed a critical appreciation of Corot to the *Scottish Art Review* which had been launched by the Boys that year.

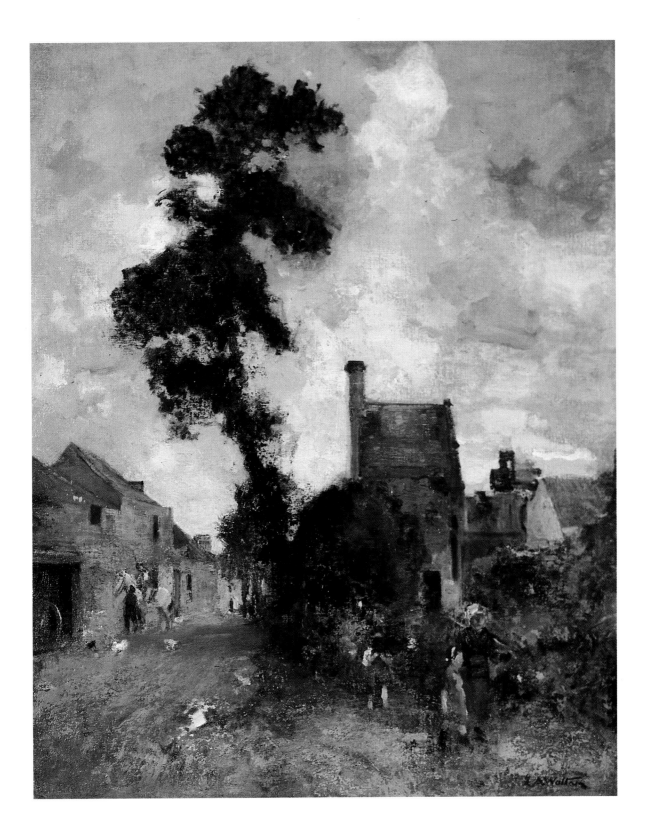

34

EDWARD ARTHUR WALTON RSA PRSW
1860–1922

The Willows

Oil on canvas, 32 × 40in (81.3 × 101.6cm)
Signed
Purchased 1982

The election of Walton and Guthrie to Associate member-ship of the Royal Scottish Academy in 1889 was sympto-matic of a gradual assimilation of the Boys into the artistic establishment in Edinburgh, as also in Glasgow. Paradoxi-cally it was in that same year that Walton spearheaded the campaign by Glasgow Art Club to acquire for the civic col-lection the portrait of Carlyle by Whistler as a permanent tribute to the most influential exponent of the Boys' own credo of 'Art for Art's sake'. From 1894, when he moved to Chelsea, Walton became a near neighbour and trusted asso-ciate of Whistler until the latter's death in 1903. The follow-ing year Guthrie, now President of the Royal Scottish Academy, induced Walton to settle in Edinburgh where, following his own election as Academician, he continued to attract a discerning clientele for his society portraiture.

Such lucrative commissions and critical acclaim did not deflect Walton from his own abiding preference for land-scape painting. From the early 1880s he had consistently refined his innate ability to integrate the disparate elements of a landscape into a balanced unity of tone and colour even in the initial phase of composition. The total effect, which was achieved by working over the whole paint surface at every stage of development, was not far removed from Corot's 'impression d'ensemble'.

Such was the appeal of Walton's lyrical visions of pasto-ral tranquillity that his manner in painting his favourite sub-jects of dappled light and contrasting patches of shadow was later frequently imitated. Especially during his early years, Walton habitually re-worked and re-dated pictures while simultaneously providing them with new titles. On other occasions he simply omitted any reference to dating. A tour de force of its kind, *The Willows* may well have been painted during Walton's last decade. In 1923 the picture was lent to the Walton memorial exhibition at the McLellan Galleries in Glasgow by a Peebleshire hosiery manufac-turer, Henry Ballantyne of Tweedvale House near Inner-leithen. Ballantyne was the last surviving representative of the family which had founded the village of Walkerburn, subsequently expanding their business into nearby Innerleithen. An accomplished amateur watercolourist and connoisseur of art, Ballantyne owned at least three other late Walton landscapes which were exhibited at the Royal Scottish Academy in 1918 and 1922.

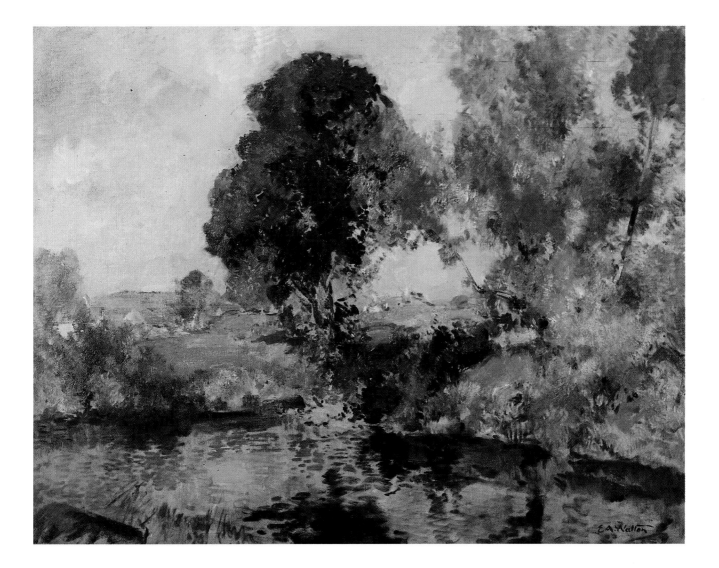

35

FLORA MACDONALD REID
1860–*c*.1940

Fieldworkers

Oil on canvas, 40 × 24in (101.6 × 61cm)
Signed and dated *1883*
Purchased 1992

Born in Islington of Scottish parentage, Reid returned with her family to Edinburgh where she trained at the Royal Scottish Academy Schools and exhibited her first painting at the age of 16. In addition she was tutored by her older brother John Robertson Reid (see no. 18) who retained an Edinburgh studio until 1879 when he appears to have settled in Ashington in Sussex. From 1881 she was mainly resident in London. Specialising in genre and portraiture, she contributed regularly from her London base to the exhibitions of the Glasgow Institute of the Fine Arts. In 1900 she was awarded a gold medal at the Exposition Universelle in Paris.

Reid travelled widely on the Continent, to Belgium, the Netherlands, Norway, and, most significantly, to France, where she could not have avoided exposure to the work of the young realist painter, Jules Bastien-Lepage. During the early 1880s Bastien-Lepage enjoyed a prodigious reputation, equally among his compatriots and as the presiding genius of the Anglo-American artists' colony at Grez-sur-Loing. Among Reid's leading contemporaries in London

two of the francophile founder-members of the New English Art Club, George Clausen and Henry Herbert La Thangue both developed a distinctive form of rustic naturalism which was initially derived from Bastien-Lepage.

At the Paris Salon of 1879 Bastien-Lepage had exhibited a highly acclaimed subject picture of potato harvesting, *La Saison d'Octobre*. In 1883, perhaps coincidentally, Reid produced at least two pictures on the same theme. In the present one Reid's indebtedness to his compositional techniques is self-evident, particularly in her monumental, as distinct from anecdotal, treatment of the principal figure. Similarly, her near-complete elimination of the foreground picture space intensifies the viewer's impression of direct engagement with an actual, identifiable individual and the general illusion of 'virtual reality' for which Bastien-Lepage was internationally admired. At the same time, the balanced compositional structure, based on an inverted triangle, has been contrived with a view to maximum decorative effect. Reid's vibrant and even slightly discordant colour scheme is peculiarly her own.

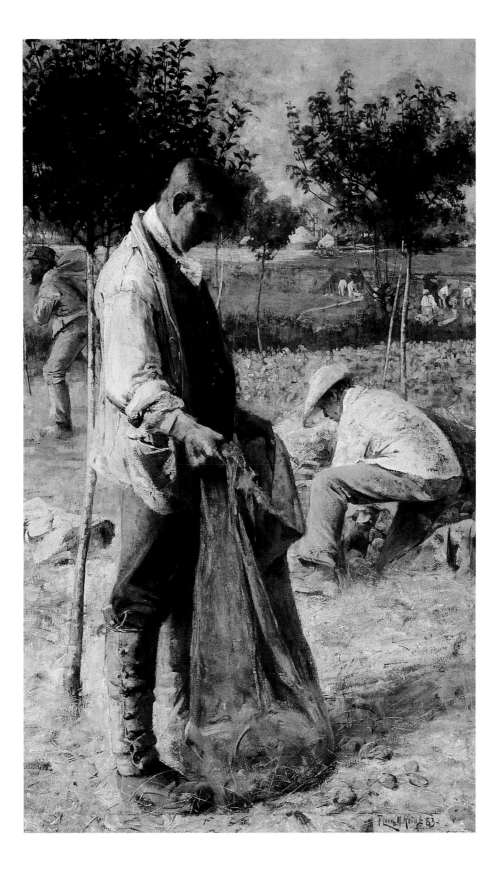

36

EDWARD ATKINSON HORNEL
1864–1933

Children at Play

Oil on canvas laid on board, 16 × 24in (40.6 × 60.9cm)
Signed
Purchased 1992

Hornel was born in Australia of Kirkcudbright parents. Unlike his great friend, George Henry, he had had a varied formal training, first at the near-moribund Trustees' Academy in Edinburgh during the early 1880s, and then at the Academy in Antwerp. He returned to Scotland in 1885 and soon settled in Galloway, where he was to spend most of the remainder of his life.

After they first met in 1885, the close relationship between Henry and the slightly younger Hornel was initially led by Henry. Although they remained good friends, only rarely did they have any direct influence on the work of each other. Their paintings are distinguished at an early stage from those of their Glasgow fellows by a common interest in the decorative possibilities of composition and colour. This came to the fore in the work of both men with collaborative projects such as *The Druids* of 1890 and *The Star in the East* of 1891 (both Glasgow Art Gallery).

Children Playing dates from 1893, immediately before Hornel set off for Japan in the company of Henry. Like much of Hornel's work at this period, the picture shows close compositional affinities with his friend's masterpiece, *Galloway Landscape*, of 1889. Perspective, scale and distance have only a minimal place in the composition. Although the steep, grassy bank, beneath a blue sky is very similar to that populated by Henry's Friesian cattle it is, typically for Hornel, a tightly restricted view, very close to the picture plane. The winding orange path, interrupted by a shock of auburn hair, is closely modelled on the stream in Henry's painting.

For all the many compositional similarities between Hornel's picture and *Galloway Landscape*, there are important distinctions to be made between the two. The present work is in an altogether higher key, reds, greens, oranges and blues predominating. After Hornel returned from Japan, the tendency towards such colours became even greater. The effect of Hornel's use of colour is not only to create a strong sense of pattern; the figures of the children, their limbs caught in motion at curious angles, both break up the landscape and become part of it, pinafores and smocks adding their own colour to the scene.

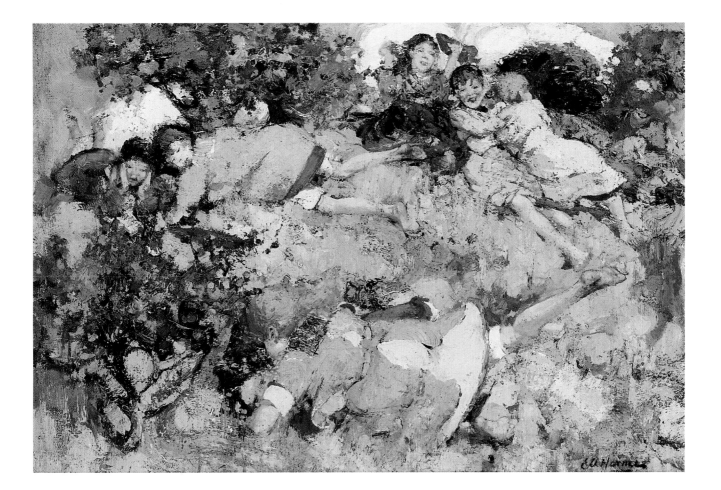

37

DAVID GAULD RSA
1865–1936

A Breton Village

Oil on canvas, 19¾ × 23¾in (50.2 × 60.3cm)
Signed
Purchased 1982

Gauld's career began unexceptionally with an apprenticeship as a lithographer which he combined with part-time attendance at Glasgow School of Art. In 1887 he was engaged by the *Glasgow Weekly Citizen* as an illustrator. This employment probably coincided with his earliest Glaswegian commissions for stained glass designs. The most important commission of this type, which was later to occupy him for a decade, was for the windows of St Andrews Scottish Church in Buenos Aires. Gauld's immediate experience of stained glass production, with its particular requirements of strong and lucid design, reinforced the decorative tendencies in his own painting style which had also become prominent in the work of Henry and Hornel. In 1889 this development attained its most radical expression in Gauld's two symbolist paintings *Music* and *St Agnes* which effectively anticipated the idioms of Art Nouveau, shortly to flourish through the enterprise of Gauld's close friend, Charles Rennie Mackintosh and his associates.

This innovatory phase was short-lived. Gauld's contemporary reputation depended on his cattle pictures which he named in mocking self-deprecation 'wolf-scarers'. These immensely successful compositions, which relied on the simplest of motifs – generally Ayrshire calves on account of their striking appearance – were painted direct from nature or worked up from *plein air* sketches and treated with a naturalism qualified by Gauld's overriding preoccupation with pattern-making. In 1903 Glasgow Corporation set the seal of civic approval on this genre when they selected one of the finest examples, *Contentment*, in order to represent Gauld in the municipal collections.

In 1896 Gauld made a painter's pilgrimage to the village of Grez-sur-Loing near Fontainebleau where Lavery, William Kennedy and Alexander Roche had sought a fresh stimulus some twelve years previously. Like his predecessors, Gauld concentrated on the village itself and the surrounding locality. The resulting series of landscape paintings, supplemented on excursions to Normandy and Brittany, introduced a greater refinement in his use of colour, a pastel-like softness, and a dreamy quality of vision which continued to characterise his later style. It was this series which commended Gauld to the newly formed International Society of Sculptors, Painters and Gravers, with whom, under the Presidency of Whistler, both Gauld and E. A. Walton exhibited for many years.

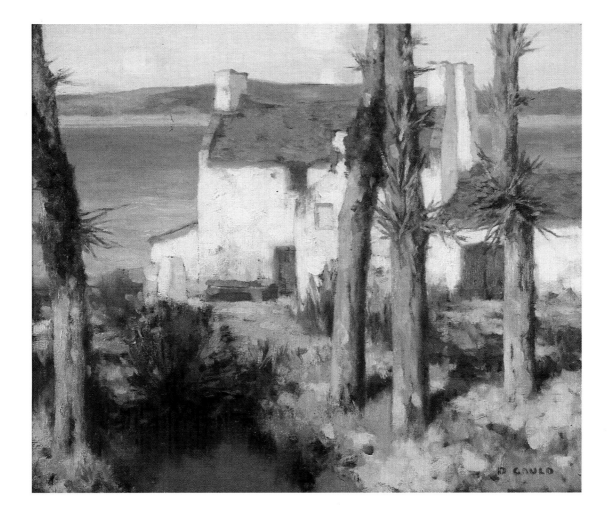

38

SIR DAVID YOUNG CAMERON RA RSA RWS RSW LLD
1865–1945

Berwick Bridge

Oil on canvas, 12 × 18in (30.48 × 45.72cm)
Signed. Inscribed and signed verso
Purchased 1988

Cameron was born in Glasgow, a child of the manse. Unwilling to follow his father into the church, Cameron left school at sixteen and worked in an iron foundry for two years while studying at Glasgow School of Art. Towards the end of 1884, after a further short period of work, this time in a solicitor's office in Perth, Cameron arrived in Edinburgh to enrol for art classes. Although there is no official record of his attendance, according to his sister, Kate, and other friends, Cameron studied at the near-moribund life school then run by the Royal Scottish Academy in a gloomy upper room in the building which is now the National Gallery of Scotland. Whether it was indeed the Royal Scottish Academy life class which he attended, or one of the other, equally uninspiring institutions for art education then available in Edinburgh, Cameron's period of study in the capital was probably as important for the opportunity which it gave him to encounter painters such as Arthur Melville and to study closely the pictures shown at the International Exhibition of 1886.

The young artist returned to his native city in 1887. By a lucky coincidence his drawings were seen by George Stevenson, the brother of the painter and critic, R. A. M.

Stevenson. George Stevenson was himself an amateur etcher and it appears to have been he who encouraged Cameron to take up printmaking, the medium through which his reputation spread most widely during the 1890s. Although he remained active as a painter, his concentration on graphic work, particularly etching, during the early years of his career, kept him on the periphery of the young group of his fellow Glaswegian painters who were then making their names in Europe.

Cameron's canvas, *Berwick Bridge,* painted in 1905, is one of several views of the town which, while in composition harking back to earlier, Whistlerian waterfront scenes, such as the etchings in his *Clyde Set* of 1889, show how far he had developed his work.

The picture was first exhibited at David Croal Thomson's Barbizon House gallery in London. It was purchased by Thomson, a close friend of Cameron's and a staunch advocate of his work. Born in Edinburgh, Thomson, was the editor of *The Art Journal* from 1892 to 1902, during which period Cameron's work was frequently given particularly good notices.

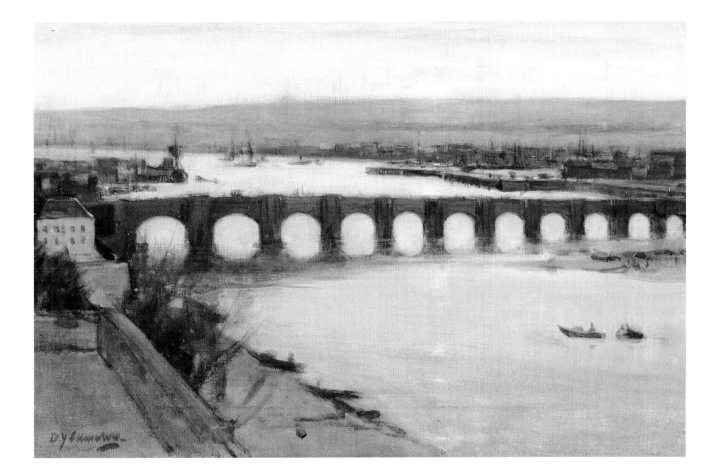

39

SIR DAVID YOUNG CAMERON RA RSA RWS RSW LLD
1865–1945

Berwick-on-Tweed

Watercolour and black chalk, 7¾ × 16¾in (19.7 × 42.55cm)
Signed
Purchased 1971

For several years during the first decade of the century, although he never abandoned printmaking, Cameron was to concentrate on his painting. The group of Borders landscapes dating from 1905 marks an important stage in Cameron's development as a painter and watercolourist. In 1903 he had been elected as an Associate of the Royal Scottish Academy and in 1904 he had become a member of the Royal Society of Painters in Watercolours.

The watercolour, *Berwick-on-Tweed*, shows many of the characteristic traits of Cameron's work on paper during the transitional stage of his development around 1905. Cameron's early landscape drawings and watercolours betray strongly his interest in printmaking, colour and wash almost applied as afterthoughts to develop the black chalk or pencil which remained the basis of the design. His early prints were essays in etching closely modelled on those of Whistler, with linear articulation of architectural detail predominating over any larger manipulation of masses for grander effect. Here the masts of distant boats can be seen picked out with a care reminiscent of the etcher's needle. Similar effects can be seen in the foreground. While the backdrop of town and bridge are, in compositional terms, similarly close to etchings of a decade earlier, there is, for Cameron, little use of line to define the contours and shapes of the architecture. Red and blue washes add richness to the otherwise grey scene.

40

SIR DAVID YOUNG CAMERON RA RSA RWS RSW LLD
1865–1945

The Tweed

Watercolour, 10¼ × 16¼in (26 × 41.2cm)
Signed
Purchased 1982

While architecture often formed a predominant feature of Cameron's work, contributing to the sense of place so important in his images, some of his finest works offer little or no trace of the presence of man in the landscape, the natural effects of sky, land and water being used to extraordinary, almost spiritual effect. *The Tweed,* a watercolour of 1905, is closely related to *The Waning Light,* a similar composition of the same date, now in the National Gallery of Scotland. In both, the slow, broad windings of the river, reflecting a cold evening sky, are the central features of the composition. The watercolour is used very much in the manner of Cameron's early Edinburgh mentor, Arthur Melville, with blots of wet pigment applied on the wet surface of the painting. In the case of *The Tweed,* however, the washes are drained of colour, in sharp distinction to the rich blues of *The Waning Light.*

The tonal treatment of landscape seen here is highly characteristic of Cameron's work at this date. This was particularly influenced by his printmaking activities, where subtle use of plate-tone, from careful wiping of the residual ink on the surface of the etching plate, was as important to the success of an impression as was the etching of detail itself. While, later on in his career, Cameron showed himself well able to use a spectacular palette in his depictions of Scottish landscape, his early mastery of this almost monochrome technique marked him out as one of the most original watercolour painters in Britain at this date. In a footnote to an article 'The Failure of our Water-Colour Tradition', published in the *Burlington Magazine* in 1905, Cameron's use of such techniques was singled out by the anonymous writer for particular praise in comparison with his contemporaries.

41

SIR DAVID YOUNG CAMERON RA RSA RWS RSW LLD
1865–1945

The Boddin, Angus

Oil on canvas, 30 × 40in (76.2 × 101.6cm)
Signed with initials
Purchased 1977

The extraordinary effects of colour sought in Cameron's later painting can be seen emerging in his early work during the early 1900s as the cool palette used by Hague School painters, on which his earlier landscapes had been based, gave way to richer, fuller colours. At the same time, when working purely in black and white as a printmaker, Cameron was following a path very close to that seen in his painting, moving away from a dependency on line towards the manipulation of mass and shadow. However, even after visits to the Mediterranean, whether to Italy, in 1900, or to Egypt, in 1908–9, Cameron never allowed his use of colour to undergo the transformations seen in the work of fellow Scots, such as Melville or, a few years later, the Colourists, after their initial encounters with brilliant sunshine and richly illuminated shadows.

Throughout his career, Cameron could be seen in his most vibrantly colourful Highland landscapes to be developing his compositions and effects with a printmaker's eye for simple distinctions of black and white. Effects of scale and mass became ever more the central objects of his attention, extraneous detail being omitted in the interests of powerful and telling contrasts and patterns. The close relationship between Cameron's paintings and his prints is well illustrated by his composition of *The Boddin, Angus,* showing a lime-kiln on the Angus coast at Lunan Bay. The artist's dry-point of the scene dates from 1911 and the magnificent canvas is roughly contemporary. Looking as though they are vast, ancient, possibly middle-eastern, defensive structures, the kilns appear to dominate the landscape. In fact, the understated details of the boats and figures, in close proximity, bring the scale and function of the kilns back into everyday terms.

42

SIR DAVID YOUNG CAMERON RA RSA RWS RSW LLD
1865–1945

Peaks of Arran

Watercolour, 13 × 19¼in (33 × 48.9cm)
Signed
Purchased 1976

Like *The Boddin,* Cameron's watercolour *Peaks of Arran* is an essay in the conjuring of scale, using the most limited of means. Ever since his Glasgow childhood, Cameron had enjoyed holidays on the island. A series of landscapes showing the mountains in the north of Arran was exhibited in 1912, presumably the date of this watercolour. While the bleak, almost lunar desolation of bare, open rock conjured in the drypoint, *Peaks of Arran,* offers almost no indication of the distances and scale being depicted, here the vast shadows of the mountain are in stark contrast to rocky foreground bathed in light, the absence of any detailed description heightening the abstract patterns of the silhouettes.

A canvas of almost identical composition, *Cir Mhor,* also dating from 1912, was the first painting by Cameron to be purchased by the City of Glasgow for Kelvingrove Art Gallery. It was exhibited later that year at the Royal Scottish Academy and is one of the finest of all Cameron's mountain paintings, the effects of light on the dramatic, silhouetted peaks being explored with a palette of black and browns. The present watercolour is more brooding and less suffused with light than the Glasgow canvas.

A watercolour of this title was exhibited by Cameron at the last of the exhibitions of the Society of Twelve, of which, with his fellow-Scot, William Strang, he had been a founding member in 1904. Although it was primarily concerned with promotion of printmaking, drawings were also exhibited by its members, who included George Clausen, William Nicholson, Augustus John and Muirhead Bone.

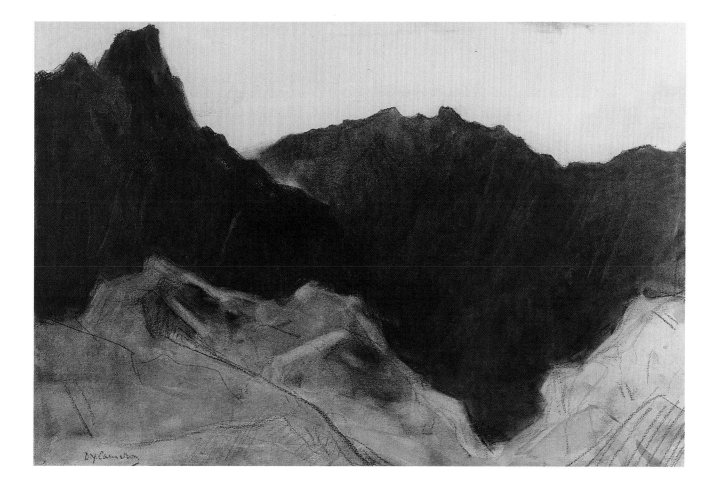

43

JOHN DUNCAN RSA RSW
1866–1945

The Turn of the Tide

Tempera on panel, 17¼ × 23¼in (44.4 × 59.7cm)
Signed
Purchased 1991

In 1905, while staying on the Outer Hebridean island of Eriskay, Duncan recorded in his private journal a vow dedicating himself to the realisation of a quintessentially mystical art. The unique symbolist painter in *fin-de-siècle* Edinburgh, Duncan was the artistic heir of David Scott and William Bell Scott and Joseph Noel Paton whose commitment to the visionary and metaphysical had represented a divergent strain in Scottish painting. During the 1890s Duncan was one of the main protégés of Sir Patrick Geddes, sociologist, town planner and intellectual guru of the Celtic Renascence movement in the Scottish capital. Through this shared quest for a truly 'national' cultural tradition, Duncan discovered in the abundant symbolism of Celtic lore and mythology his spiritual homeland and ideal mode of self-expression. For the ostensible subjects of his most ambitious compositions Duncan favoured specific figures from Celtic mythology such as Cuchulain, Deirdire or St Bride. Their archetypal symbolism often encompassed meanings private to the artist. On occasion a pure landscape would be invested with an obscure allusiveness which may or may not have been related to a definable literary source. Of itself, the title *The Turn of the Tide* is as multivalent as the enigmatic female figure in the foreground of the picture, rapt in a trance of anticipation, grief or foreboding, perhaps even in the contemplation of death itself.

In the 'many coloured lands' of the Western Isles, Duncan responded – as the Scottish Colourists were to respond after him – to landscapes whose natural appearance invited abstraction. From 1910 he experimented extensively with tempera as his preferred medium for 'dream landscapes' or 'two-spots'. His overriding desire for simplicity in design and enamel-like density of colour forced him into a continual process of revision. This undated picture probably belongs to a slightly later period when Duncan began to plan his compositions in watercolour before embarking on the rigours of their translation into tempera.

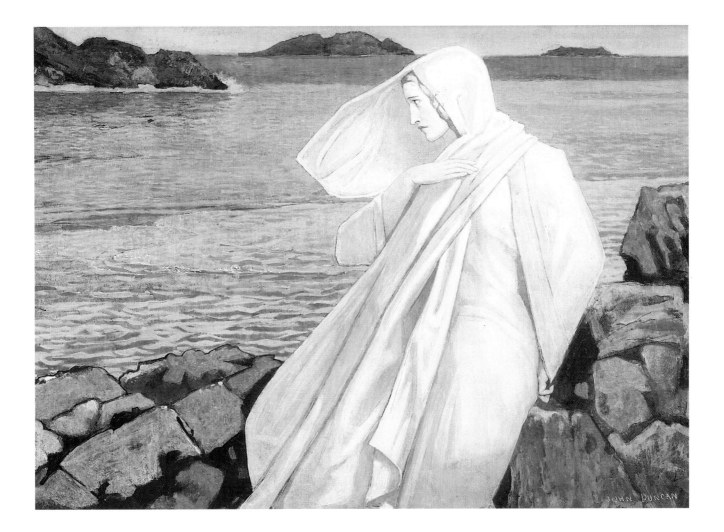

JAMES PRYDE
1866–1941

The Unknown Corner

Oil on canvas, 34 × 28in (86.3 × 71.2cm)
Purchased 1988

Through his mother Pryde was descended from two noted Scottish artists, Robert Scott Lauder, one of the most influential Masters of the Trustees' Academy in Edinburgh, and J. E. Lauder, the genre and landscape painter. In 1886 Pryde enrolled at the Royal Scottish Academy Schools as a contemporary of D. Y. Cameron. Two years later Pryde was introduced to E. A. Walton and James Guthrie who had singled out his work at the Academy's exhibition. This valued contact with the Glasgow Boys was later extended to Joseph Crawhall and Charles Rennie Mackintosh, although Pryde himself stood aloof from any organised artistic movement.

By 1890 he had joined his sister Mabel at Herkomer's Academy in London where he encountered William Nicholson, shortly to become his brother-in-law. In 1894 the actor Edward Gordon Craig commissioned posters for a new production of *Hamlet.* From 1894 to 1896 Nicholson and Pryde collaborated as the 'Beggarstaff Brothers', effectively revolutionising poster design in Britain. In contrast, Pryde's output as a painter was curtailed by his slow working methods and natural indolence and he failed to capitalise on a talent which was recognised as being exceptional by the time of his first solo show in 1911.

The following year the *Athenaeum* gave extended coverage to *The Unknown Corner* as 'the most strikingly successful work' at the Goupil Gallery Salon. In 1933 the picture's singular qualities justified its re-selection for the Pryde retrospective at the Leicester Galleries. In this deceptively simple and almost monochromatic composition, Pryde reveals his consummate mastery of an art of omission which is synonymous with an art of compelling suggestion. The massive central arch minimises the physical and narrative importance of the Lilliputian human figures below and intensifies the all-pervasive aura of menace and expectancy. The imminent drama thus implied remains enigmatic.

Pryde's attachment to this particular architectural motif with its resemblance to a proscenium arch owed much to his lifelong fascination with the theatre. His architectural fantasies – he invariably worked from recollection rather than from actuality – also recall the capriccios of Francesco Guardi which he could have seen in Venice in 1911. Most especially, Pryde's sense of the macabre and his ability to induce an atmosphere of claustrophobic intensity suggest his empathy with Piranesi, both as the author of the *Carceri d'Invenzione* and the celebrated Roman *Vedute*.

45

EDWIN JOHN ALEXANDER RSA RWS RSW
1870–1926

The Rooster

Watercolour on grey packing paper, 37 × 46¾in (94 × 118.7cm)
Signed and dated *'99*
Purchased 1989

Alexander was the son of the Edinburgh-based painter of sentimental animal subjects, Robert Alexander. Alexander senior was a close friend and occasional travelling companion of Joseph Crawhall, from whose animal subjects the younger man was to learn much. In 1887 Alexander junior joined Crawhall and his father on a visit to Morocco. After a brief period of study in Paris, in the studio of the animal sculptor, Emmanuel Fremiet, Alexander travelled extensively in Egypt, in the company of Erskine Nicol Junior, between 1892 and 1896. His studies of daily life in the desert, characterised by dull, grey and buff tones, are in marked contrast to the glowing brilliance of watercolours by Arthur Melville, also based on North African visits.

After Alexander returned to Scotland, he settled in East Lothian where he kept a collection of animals and birds to use as models in his pictures which were almost invariably in watercolour on paper, linen or silk, the latter techniques being borrowed directly from Crawhall. Within a very few years, his reputation had spread throughout Britain and he was elected to the Royal Society of Painters in Watercolour in 1910, the year before he was similarly recognised by the Scottish watercolourists' society.

Although Alexander's watercolours of botanical, bird and animal subjects were strongly influenced by his father's friend, his depictions of nature are rather more prosaic and less stylised than those of Crawhall. *The Rooster*, which dates from 1899, is a fine example of Alexander's work from this period, painted, as were many such pictures, on grey packing paper. Rather like his father, Alexander is here content to place his principal subject in the centre of the composition, viewed in profile, surrounded by his flock: Though stylish in the handling of his medium, Alexander remained steadfastly rooted in an earlier tradition of animal painting, in stark contrast to Crawhall, whose own treatment of an almost identical subject, now in the Burrell Collection, Glasgow, heightens the abstract elements of the composition, emphasising the decorative qualities of the whole picture.

46

SAMUEL JOHN PEPLOE RSA
1871–1935

Flowers in a Silver Jug

Oil on panel, 10 × 13¾in (25.4 × 34.9cm)
Signed
Purchased 1980

Peploe, the eldest of the Scottish colourists, was born in Edinburgh. His father, a banker by profession, died in 1884, leaving Peploe to be looked after by trustees who were most unwilling for the young man to train as a painter. After a short period working in an Edinburgh solicitor's office, in 1893 Peploe was enrolled at the Edinburgh School of Art, then run by the Royal Scottish Academy. The following year, Peploe attended the Académie Julian in Paris and the Académie Colarossi, where he won a medal. On his return to Scotland he made the first of what were to become regular visits to the Western Isles. After the Great War, over a period of almost a decade, these summer excursions were made in the company of Cadell, the two men often painting side by side on Iona.

During the late 1890s, in a series of richly painted figure subjects and still-lifes, Peploe's palette had been influenced as much by the pictures of Velázquez and Hals as by Manet and Courbet. By 1904, the probable date of the panel, *Flowers in a Silver Jug,* such still-lifes had a much greater sense of light, though their tonal range remained subdued. An almost identical composition, painted on canvas rathr than on panel, (Private Collection) shows the same silver jug, without the flowers, together with the fan, a pile of books and another oil sketch in the background. The present picture has an interesting provenance, having belonged to John Cowan, an Edinburgh paper manufacturer and a notable collector of modern British and Continental painting. A friend of both Peploe and Cadell (whose painting *The Dunara Castle at Iona,* no.56, belonged to Cowan) and several of the Glasgow Boys, Cowan was persuaded by Sir John Lavery to sit to Whistler in 1893. The portrait, unfinished, is now in the National Gallery of Scotland.

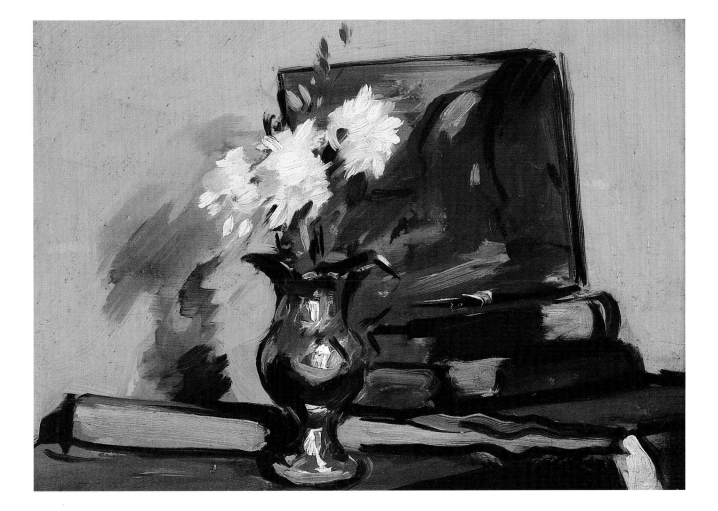

47

SAMUEL JOHN PEPLOE RSA
1871–1935

Lady in a White Dress

Oil on panel, 12 × 14in (30.4 × 35.5cm)
Purchased 1968

The *Lady in a White Dress* dates from 1906. It is one of a series of such figure studies painted by Peploe in the studio in York Place to which he moved in 1905. The artist had held his successful first solo exhibition in Edinburgh at Aitken Dott in 1903 (from which J. D. Fergusson had purchased a still-life of melon, grapes and apples). It was as a result of this exhibition that Peploe was able to establish himself in one of the finest studios in the city. The artist's new painting room was that designed by Sir Henry Raeburn, almost exactly a century before, and the remarkable system of adjustable window shutters devised by his illustrious predecessor encouraged the young painter to take full advantage of the brilliant northerly light coming, uninterrupted, across the city from the Firth of Forth.

The sitter, called Peggy Macrae, was a popular model with many of Peploe's Edinburgh contemporaries. The silvery tones of the picture's fluid and creamy brush strokes derive in part from the artist's studio, which Peploe had decorated with a grey and pink colour-scheme.

48

SAMUEL JOHN PEPLOE RSA
1871–1935

Paris Plage

Oil on board, 8½ × 10½in (21.5 x 26.6cm)
Purchased 1970

The new light tones and fluid colours seen in *Lady in a White Dress* can also be seen in the little landscape, *Paris Plage,* of about 1907. This little panel is one of numerous such pictures painted in France by Peploe, in the company of J. D. Fergusson, during these years. The two had first visited Brittany together in the summer of 1904. While at first Peploe continued to use the muted colours seen in his Edinburgh pictures of the period, the effects of the southern light and the influence of contemporary French painting which so predominate in the work of Fergusson at this time, soon began to heighten Peploe's palette.

Peploe moved, with his wife, to Paris in 1910, remaining there for two years. The experience which he gained of contemporary French painting was of great importance to his development as a painter, particularly in his use of colour. The pictures which he produced were not a commercial success however and in the summer of 1912, the Peploe family returned to Edinburgh.

The apparent fluidity and ease of the brush work in small pictures such as *Paris Plage* was not always achieved without some difficulty. Peploe's brother-in-law recorded 'with what dexterity and precision' the figures in a *plein air* painting in Perthshire 'took their place in the picture … It was in such cases that his masterly draughtsmanship was revealed; with a few strokes of his brush those objects became living things.' On another day however, 'He had a difficulty in getting the proper curve of [a] tree to carry out the rhythm of the picture … I remember that six attempts were made before he was satisfied … for here, as in all his pictures, the final result must show no ambiguity. It had to be accomplished without any signs of hesitancy or weakness in the technique.'

49

SAMUEL JOHN PEPLOE RSA
1871–1935

Kirkcudbright

Oil on canvas, 21 × 25in (53.3 × 63.5cm)
Signed
Purchased 1978

After the Peploe family returned to Scotland in 1912, they made several excursions to the south west. *Kirkcudbright* dates from 1914 and marks a new, angular approach to landscape in Peploe's work, the blacks and greens with which the topography is described, being applied in regular, directional patterns very different from the fluid brush strokes of only a few years earlier. The home of a small community of painters centred around E. A. Taylor and Jessie M. King, the town became a fruitful subject for Peploe over several summer seasons until 1920, when Cadell persuaded Peploe to visit Iona instead.

The picture formerly belonged to the notable Aberdeen collector, Sir Thomas Jaffrey. Jaffrey, a local businessman with a wide variety of interests, was chairman of the Aberdeen Art Gallery Committee for over twenty years until his resignation in 1951. Jaffrey died in 1953. After the death of his second wife, his large collection of pictures, including a substantial group of works by Scottish artists, was sold. Jaffrey had several works by Leslie Hunter, as well as those by Peploe. A catalogue of the collection, privately published in 1948, noted that 'He has often said, "If a picture does not give me joy, I have no use for it".'

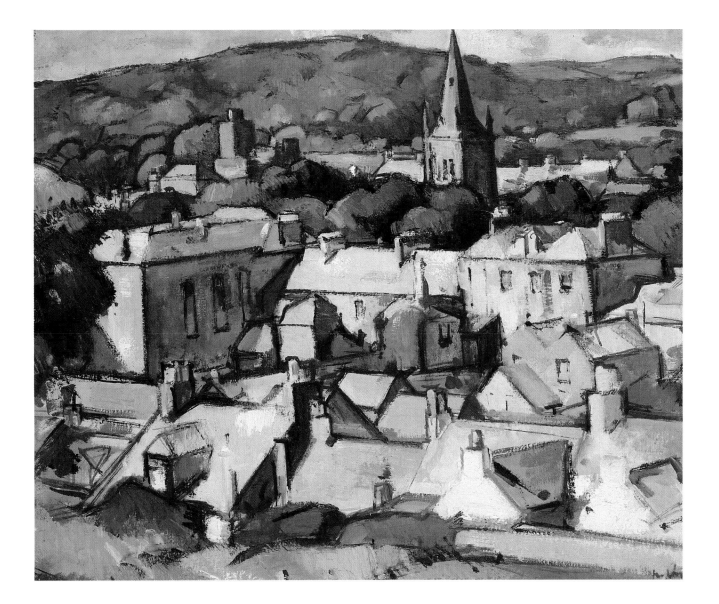

50

SAMUEL JOHN PEPLOE RSA
1871–1935

A Vase of Pink Roses

Oil on canvas, 8⅝ × 7⅞in (22 × 20cm)
Signed
Purchased 1968

A Vase of Pink Roses dates from *c.*1925. Peploe's career was at the peak of its success, in terms of exhibitions, sales of his pictures and of honours. This success culminated in 1927 with his election to the Royal Scottish Academy. It was another still-life of pink roses and fruit, purchased with an Iona seascape, at an exhibition at the Reid Gallery in Glasgow in 1924, which formed the basis of one of the finest collections of Colourist pictures between the Wars, created by the shipbuilder, Ion Harrison

Still-life painting had always been a central feature of Peploe's work and, over the course of the 1920s, he spent much time attempting to perfect his responses to the patterns and relationships created by his studio arrangements. By the time that the present picture was painted, instead of creating the sense of movement which often features in his still-lifes of the period of the Great War, Peploe was making the picture planes flatter and enlivening them with the abstract patterns of drapery and of bowls of fruit, punctuated, as here, by a vase, almost invariably filled with roses or tulips. If at times such pictures do suffer from a formulaic predictability, they were, nonetheless, considered attempts by Peploe to develop his painting and solve the problems with which he was presented by still-life painting.

51

JOHN DUNCAN FERGUSSON RBA LLD
1874–1961

Jean Maconochie

Oil on canvas, 24 × 20in (60.9 × 50.8cm)
Purchased 1981

Although Fergusson was born in Leith, his family roots in Perthshire were always particularly important to him. He and his wife, the dancer Margaret Morris, moved to Glasgow in 1939 and he became closely associated with the artistic life of that city over the next twenty years. After a short period of training for the medical profession, Fergusson enrolled at Edinburgh School of Art. Finding rigorous academic methods uncongenial, he abandoned his course, acquired a studio in Edinburgh and taught himself to paint. In the mid-1890s, he moved to Paris, where he attended life classes at the Académie Colarossi, although these too he found over-constraining. During the next decade, Fergusson spent much time in France, both in Paris and along the coasts of Normandy and Brittany, where he spent several holidays in the company of his lifelong friend, S. J. Peploe. He also travelled to Spain and North Africa. From 1907 until the outbreak of the Great War, Fergusson lived in Paris, where he absorbed the influences of contemporary French painting more completely than any of his Scottish contemporaries.

Although many of Fergusson's initial influences came from elder Glasgow School contemporaries, particularly Arthur Melville, this was more in terms of Melville's painterly use of colour than in choice of composition or subject matter. Ultimately, of all the colourists, Fergusson showed, both in his painting and in his vitriolic tract *Modern Scottish Painting*, published in 1943, the liberating results of lengthy contact with French painting. He developed a powerful and decorative approach to colour, his most distinctive paintings of the late 1900s showing a considerable understanding of painters such as Matisse.

In the first years of the 1900s, Fergusson, like Peploe, used the muted colours found in Manet's paintings of the 1860s to particular effect. Peploe had also been particularly influenced by the free handling and direct brushwork of Frans Hals, after a visit to Amsterdam in the mid-1890s. Here the same influences are clearly apparent in Fergusson's painting, which dates from 1902: the directness of both composition and handling owes much to the 17th-century Dutch master.

52

JOHN DUNCAN FERGUSSON RBA LLD
1874–1961

Jonquils and Silver

Oil on canvas, 20 × 18in (50.8 × 45.7cm)
Signed and dated '05 on the back of the canvas
Purchased 1971

Like his fellow Scottish colourists, Fergusson was a great admirer of Manet. The influence of the French painter's muted palette of pinks and silvery-greys can be seen clearly in this still-life, which dates from 1905. Similar compositions, with rich dark backgrounds and thickly painted linen cloths are also characteristic of Peploe's work of the early 1900s. The two men had become great friends, Fergusson buying one of Peploe's still-lifes at the latter's first solo exhibition at Aitken Dott in Edinburgh in 1903. Fergusson's own first one-man exhibition was held in London in 1905. Although Fergusson maintained his studio in Edinburgh at this time, he was more inclined to work out of doors, often on a tiny scale, producing dozens of small panels of swiftly painted scenes of urban life.

The long-standing title of the picture is something of a mystery: the most prominent flowers in the painting, their pink colour so crucial to the composition, both in the vase and on the table, are carnations. It is interesting to compare Fergusson's efforts in this picture with those of Peploe, whose successful still-lifes had clearly encouraged him. By 1905, Peploe's large-scale and formal still-lifes, although retaining their dark backgrounds and white cloths, had begun to move towards a level of abstraction, coupled with a dramatic use of primary colour, entirely missing from Fergusson's canvas. The picture dates from the year in which he painted his well-known *Dieppe, 14th July 1905: Night* (Scottish National Gallery of Modern Art), in which Whistler, rather than Matisse, is the predominant influence.

53

GEORGE LESLIE HUNTER
1879–1931

Ceres, Fife (Fifeshire Village)

Oil on canvas, 24 × 20in (60.9 × 50.8cm)
Signed
Purchased 1977

Born at Rothesay, on the Isle of Bute, Hunter emigrated with his family to San Francisco in 1892 after two of his elder brothers died of tuberculosis. His father, a pharmacist by profession, spent seven years as an orange farmer in California before returning, homesick, to Scotland. His son, who had taught himself to paint, remained in America, working as an illustrator. Shortly after his father's death, in 1900, Hunter travelled to Europe, apparently spending some time both in Scotland and in Paris.

Although he probably had no opportunity to undertake any formal tuition even at this stage in his career, the experience of contemporary European painting must have been a vital one in his development. Sadly little is known of Hunter's work from this period. Having returned to California, via New York in 1905, he was offered his first one-man exhibition. Only a matter of days before it opened, the great San Francisco earthquake of 1906 destroyed what few possessions he owned, together with his pictures. Disillusioned, he returned to Europe, firstly to Glasgow and then London, working as an illustrator in between visits to Paris.

One of the few truly productive and financially successful periods in Hunter's career was that, shortly after the end of the Great War, when he started to spend regular periods in Fife. At this time his painting became increasingly energetic and unrestrained in its handling and use of colour, showing a marked contrast to the ever more controlled and rational painting manner of his fellow Colourists, Peploe, Cadell and Fergusson. The pictures painted in Ceres and Largo during the early 1920s sold particularly well, especially among the well-to-do collectors of Dundee and Glasgow, and, to a lesser extent, Edinburgh, who had for many years spent their family holidays in this part of Fife.

54

GEORGE LESLIE HUNTER
1879–1931

Lower Largo, Fife

Oil on millboard, 8 × 20¼in (20.3 × 51.4cm)
Signed
Purchased 1969

Always something of an outsider among his Scottish Colourist contemporaries, Hunter would often 'disappear' for days at a time, dogged apparently by mental problems. Even during the 1920s, when, through influential patrons such as the dealer, Alex Reid, Hunter was as financially secure as he had ever been, paranoia and lack of concern for his own well-being brought about a slow decline in his physical condition. After a brief period in London in 1931, he returned, seriously ill, to Glasgow, where he died in December of that year.

The two canvases by Hunter in this exhibition date from the early 1920s and are typical of the pictures which he produced at this period. *Lower Largo, Fife,* in particular, has an early provenance which well sums up Hunter's critical and commercial success at the time. Much admired by Alex Reid, Hunter's work was stocked on a regular basis by Reid's gallery. This painting was purchased by Dr T. J. Honeyman, whose *Introducing Leslie Hunter,* published in 1937, was the first monograph on the artist. Honeyman, later to become Director of Glasgow Museums, was practising as a family doctor in Glasgow until 1929. In his autobiography, *Art and Audacity,* Honeyman notes that he had first met Hunter in 1924 and that in studying art, it was due 'more to him than to any other individual that I began to do my own thinking.'

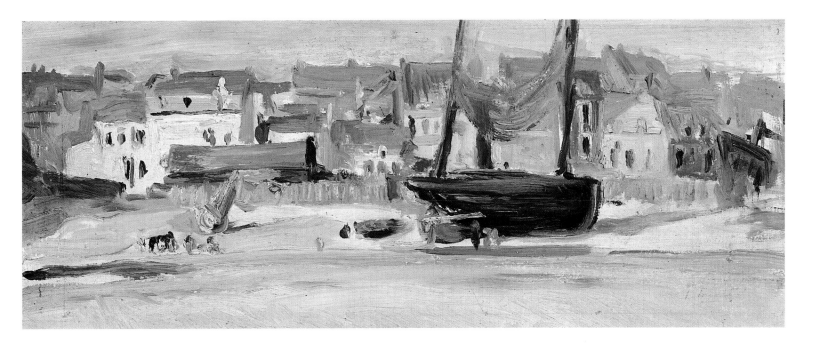

55

FRANCIS CAMPBELL BOILEAU CADELL RSA RWS
1883–1937

The Feathered Hat

Oil on millboard, 18 × 14in (45.7 × 35.5cm)
Signed
Purchased 1992

Cadell was born in Edinburgh. His father was a friend of Arthur Melville, on whose suggestion Cadell attended what was then the Royal Scottish Academy-run Edinburgh School of Art (shortly to become Edinburgh College of Art), before spending three years in Paris at the Académie Julian from 1899–1902. Apart from a short period spent in Munich in 1907 and a trip to Venice in 1909, Cadell lived for most of the remainder of his life in his native city, making annual summer painting excursions in Scotland, to Iona and, on occasion, to the Continent.

The Feathered Hat dates from about 1915, shortly before Cadell joined the army and was sent to fight in France. Cadell had recently become a close friend of S. J. Peploe, who returned from studying in Paris in 1912. Peploe's use of freely handled paint was highly influential on Cadell and the rich yet sombre colour in this picture, vigorously applied, is entirely characteristic of a number of treatments of such subjects by the artist, dating from this period.

Of his fellow Scottish Colourists, Cadell was by far the most gregarious. Honeyman's comment that 'his vivid personality was apt to intrude itself between picture and spectator', while apparently a fair indication of Cadell's clubable attitude to life, is also a reflection of the atmosphere of elegant style conjured up in these figures from New Town drawing-rooms. As with contemporary portraits by Lavery and Sargent, stylish composition and handling is an extension of the stylish subjects depicted.

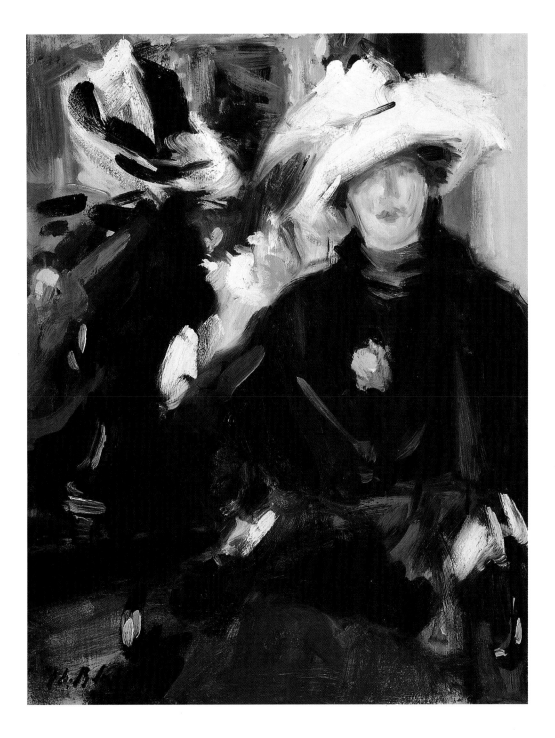

56

FRANCIS CAMPBELL BOILEAU CADELL RSA RSW
1883–1937

The Dunara Castle at Iona

Oil on millboard, 15 × 18in (38.1 × 45.7cm)
Signed
Purchased 1970

The Dunara Castle at Iona dates from about 1929. Painted in an altogether higher key than *The Feathered Hat,* the picture is typical of Cadell's work at this period. Following a visit to Cassis in about 1920, where the brilliance of light and colour in the landscape was a far cry from anything to be seen in Scotland, Cadell's palette altered, in much the same way as had that of J. D. Fergusson after he settled in the south of France in 1913. The rapid, *plein-air* painting techniques used by the artist for his views on Iona and Mull were easily adapted to his love of stylish handling of pigment and colour, many of these canvases being completed in a single sitting.

Cadell first visited Iona in about 1913. He returned there every summer for twenty years, joined, during the 1920s, by Peploe and his family. Although they worked in close proximity, the two men reacted to their Island subjects in very different ways. While Peploe returned repeatedly to views such as that of Ben More on nearby Mull, his palette maintaining the cool and muted tones which he used in the south of France, Cadell's reaction was increasingly to use brilliant reds, blues and greens, applied, as here, in areas of brilliant, sometimes pure colour.

Cadell's last years were dogged by misfortune. Weakened by cancer and rarely able to sell his work for substantial prices, he became dispirited and had to move into increasingly modest accommodation. Finally, in 1936, the year before his death, Cadell had to turn to the Alexander Nasmyth Fund for the Relief of Decayed Scottish Artists.

Like Peploe's *Flowers in a Silver Jug,* no.46, *The Dunara Castle* belonged to Cadell's friend and patron, the Edinburgh paper maker, J. J. Cowan.

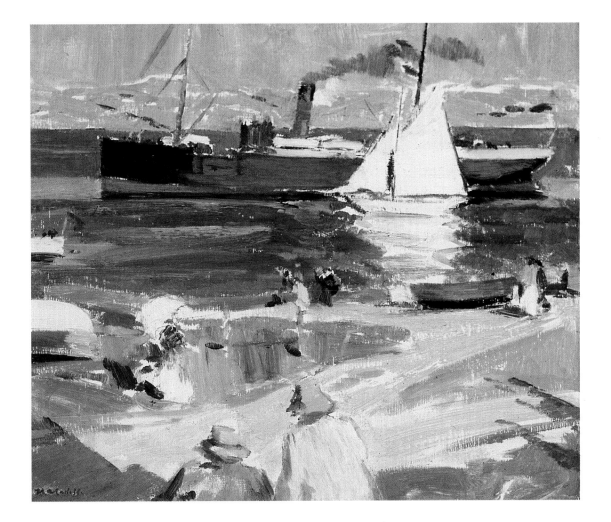

57

ERIC HARALD MACBETH ROBERTSON
1887–1941

Robert the Bruce and De Bohun

Oil on canvas, 27 × 34in (68.5 × 86.3cm)
Purchased 1990

At the turn of the century Robertson moved from Dumfries to Edinburgh where, in 1907, he abandoned his initial studies in architecture in favour of painting. Exceptionally gifted, but widely censured for the perceived decadence of his lifestyle and subject matter, Robertson remained throughout his career an eclectic and experimental figure painter. Drawing his early inspiration from Rossetti, Burne-Jones and Moreau and intensive reading of Swinburne, Yeats and Maeterlinck, he was also an acolyte of John Duncan with whom he visited J. D. Fergusson during an excursion to Paris in 1910. Two years later Robertson helped to found the Edinburgh Group. The Group's second exhibition, which was staged at the New Gallery in Shandwick Place, included work by Cecile Walton with whom Robertson embarked on a troubled marriage in February 1914.

The first year of their marriage was strained by extreme financial hardship, relieved by a few commissions from Patrick Geddes. In July Robertson, with some collaboration from Cecile, was working on a small picture of *The Battle of Stirling Bridge*. In style and tonal range the finished composition is strongly reminiscent of the cycle of narrative mural paintings commissioned from William Hole for the Scottish National Portrait Gallery. This genre was characterised by unresolved tensions between a desire for historical authenticity and an essential literariness of interpretation conducive to pictorial myth-making on an epic scale. Probably conceived as a pendant to *Stirling Bridge,* Robertson's depiction of the famous encounter between Robert I and Henry de Bohun on the eve of the Battle of Bannockburn is equally exceptional in the general context of his work.

In June 1914 there were public celebrations in Stirling commemorating the 600th anniversary of Bannockburn as the 'red-letter day of Scottish Nationality'. Some months previously Glasgow Corporation had initiated a memorial competition for paintings representative of an episode or epoch in Scottish history. In October fifty of the competition designs were exhibited at the Kelvingrove Art Gallery, two later being purchased for the City's collection. Predictably many of the paintings focused on the Battle of Bannockburn itself or the killing of De Bohun. Robertson contributed *Stirling Bridge*. The prospect of a prize of 400 guineas and a civic commission offered to the successful contender explains his unique venture into history painting for which he otherwise showed no aptitude.

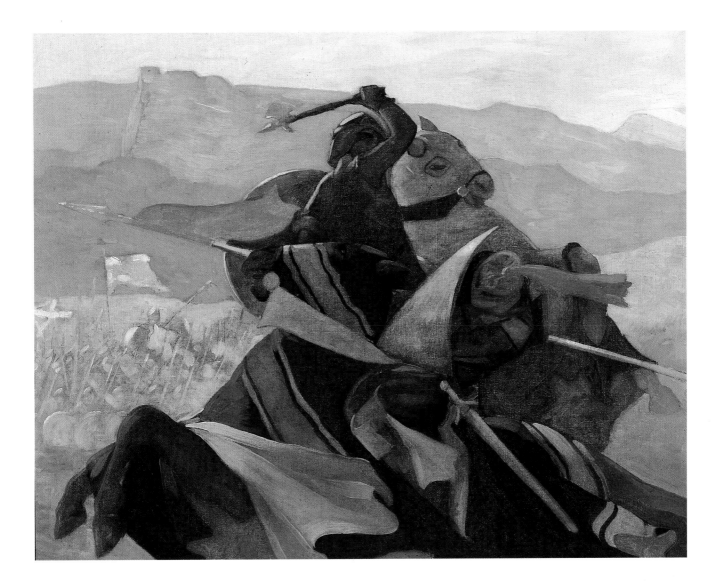

58

STANLEY CURSITER CBE RSA RSW LLD
1887–1976

Reclining Lady in White

Oil on panel, 10½ × 14½in (26.7 × 36.8cm)
Signed
Purchased 1982

From Kirkwall in Orkney, where he attended school with Edwin Muir, Cursiter moved to Edinburgh to follow his ambition of a career in architecture. After serving an apprenticeship as a chromolithographic designer, he was admitted to the new Edinburgh College of Art. From 1909 he established himself as a designer, while also painting landscapes and seascapes during summer excursions to Shetland and Orkney. Two years later he encountered Roger Fry and Clive Bell at the first Post-Impressionist exhibition in London and, on his own election to the Society of Scottish Artists, arranged for a selection of the exhibits to be shown in Edinburgh – a remarkable initiative which exposed the wider Scottish public to the achievements of Gauguin, Cézanne, Van Gogh and Matisse. Cursiter's own response to the challenge of evolving a modernist idiom was explored in a series of Futurist paintings of Edinburgh in 1913. These found no sequel in his later work which, by his own admission, was far more conventional and increasingly oriented towards portraiture.

Cursiter's second career as a pioneering and visionary art gallery curator and administrator began in 1925 on his appointment to the Keepership of the National Galleries of Scotland with particular responsibility for the Portrait Gallery. In 1938, as Director of the Galleries, he launched an abortive proposal for the founding of a gallery for modern art with a view to stimulating new design and an enhanced appreciation of Scottish art. A decade later he resigned from the Galleries in order to resume full-time painting in his native Orkney.

In 1947 Cursiter published an *Intimate Memoir of S. J. Peploe* (see no.51), drawing on his personal recollections of a contemporary with whom he evidently sensed a special affinity. This captivating study of a *Reclining Lady* invites comparison with the early style of both Peploe and Fergusson in which French influence was predominant. The picture might also be described as Cursiter's passing tribute to the supremacy of Manet who had featured in Fry's epoch-making Post-Impressionist exhibition at the Grafton Gallery in London. Many of Peploe's early works were characterised by ample, bold and fluent brushwork and a decided preference for a restricted palette. Within the self-imposed limitations of this cabinet picture, Cursiter displays a similar command of bravura handling and a sensuous delight in the tactile quality of the paint itself.

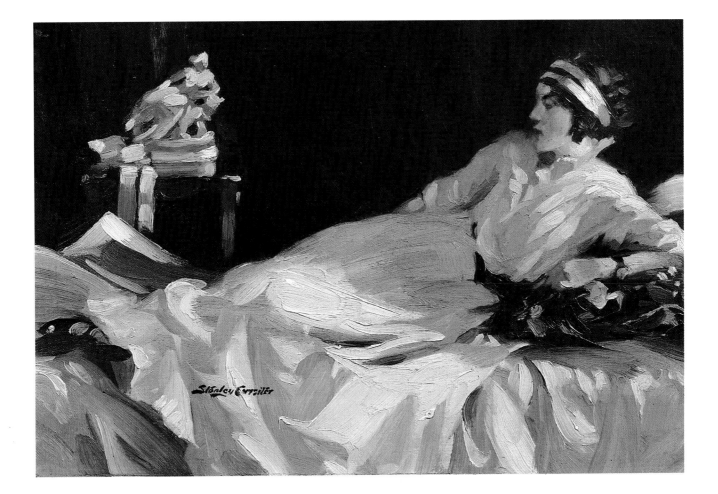

59

DOROTHY JOHNSTONE ARSA
1892–1980

Cecile Walton

Oil on canvas , 42 × 60in (106.6 × 152.3cm)
Signed and dated *September 1918*
Purchased 1987

As a tribute from one brilliant woman painter to another, this informal yet strikingly monumental portrait of the daughter of E. A. Walton celebrates the creative vitality of two of the young artists associated with the Edinburgh Group around the time of the First World War. The daughter of the landscape painter George Whitton Johnstone RSA, Dorothy Johnstone studied under E. A. Lumsden at the newly-founded Edinburgh College of Art. It was at John Duncan's studio that she first encountered Cecile Walton. Through E. A. Walton Johnstone was introduced to Sargent, the acknowledged master of society portraiture and a lasting influence on her own work as a portrait and figure painter. During these years the bond between Dorothy and Cecile was strengthened by a shared professional and personal interest in Eric Robertson before Robertson's controversial marriage to Cecile in 1914. That year Johnstone secured an appointment on the staff of the College of Art, a position which she was obliged to relinquish after her marriage to D. M. Sutherland in 1924.

During the intervals between teaching she became a frequent visitor to Kirkcudbright which, by the war years, attracted a mobile international colony of some fifty practising artists. Robert Burns, the first Head of Painting at Edinburgh College of Art, was convinced that no student's formation could be complete without the stimulus of an interlude in Kirkcudbright. As a permanent colonist E. A. Hornel had been followed by Jessie M. King who had purchased the 18th-century house and outbuildings later renamed 'The Green Gate'. From 1913 the dependant cottages restored by King and her husband E. A. Taylor were leased to other artists. Among these migrants there was a coterie of women painters and designers, mostly Glasgow-oriented, but including Johnstone.

Over the summers she was often to be seen cycling around the Galloway countryside with large canvases strapped to her bicycle in pursuit of subjects to be explored through *plein air* painting. During Eric Robertson's prolonged absence in France with the Friends' Ambulance Unit from 1917–1918 she invited Cecile to join her at the Greengate Close. The resulting portrait revealed a new dimension to Johnstone's figure painting in its experimental combination of an outdoor setting with a decorative effect achieved by the choice of an unusual, if entirely natural, near-horizontal pose for her model.

60

SIR JAMES GUNN RA
1893–1964

The Eve of the Battle of The Somme

Oil on canvas, 33 × 36in (83.8 × 91.4cm)
Signed and dated *1916*
Purchased 1995

Gunn was born in Glasgow, the son of a tailor. After a brief period at Glasgow School of Art, he enrolled at Edinburgh College of Art in 1910. Gunn spent some time in Paris, before settling in Scotland, where he exhibited his first two portraits at the Royal Scottish Academy in 1913. Although his reputation was to be made as a portrait painter, Gunn's early success came with fluently painted landscapes, painted in France and Spain before the First World War. After his demobilisation, he settled in England, although he continued to maintain strong links with his native Glasgow.

This picture is the only finished canvas known to have survived from Gunn's service in France with the Artists' Rifles. Gunn had already lost one brother, killed in 1915, and he himself was gassed during the course of the War. His brother Charles, who was also to be killed, in 1917, saw the picture in Gunn's barracks in September 1916 and wrote 'Gee Whiz it's a knockout … Really it is a glorious thing and the Artist has lost none of his cunning.'

Presumably, the scene of soldiers at rest was painted without any intention that its idyllic pastoral subject should have the horrifically ironic overtones now implied by its title. It must have been completed some time before the start of the Battle of the Somme on 1 July, on which day alone, 20,000 British troops were killed.

Acknowledgements

In researching this exhibition we have been assisted by many individuals who have responded to last-minute enquiries with exceptional generosity. We are particularly grateful to the following:

Aberdeen Central Library, Local Studies Unit; John Ballantyne; Dr Iain Brown, Iain McIver and Elspeth Yeo, National Library of Scotland; Ruth Calvert, Midlothian Library Headquarters; Dundee Central Library, Local Studies Unit; Dr Lindsay Errington, Aberdeen Art Gallery; Ian Fisher, Ian Gow, Dr Miles Oglethorpe and Veronica Steel, National Monuments Record of Scotland; Pauline Gallagher, University of Strathclyde Archives; Glasgow Room, Mitchell Library, Glasgow; Dr Vickie Hearnshaw; Graeme Hopner, Dumbarton District Libraries; John Hume, Historic Scotland; Sir Peter and Lady Hutchison; Francina Irwin; Anne and John Kemplay; Langley-Taylor; Kitty Michaelson, Patrick Geddes Centre, University of Edinburgh; Andrew McIntosh Patrick and Peyton Skipwith, The Fine Art Society plc; Jeremy Rex-Parkes, Christie's Archives; Anna Robertson, McManus Galleries, Dundee; Nicholas Savage, Royal Academy Library; Kim Sloan, British Museum; Joanna Soden, Royal Scottish Academy; Hugh Stevenson, Glasgow Art Gallery and Museum; Paul Stirton, University of Glasgow; Ailsa Tanner; George Woods, McLean Museum and Art Gallery, Greenock.

Our greatest debt is to Bill Smith of Flemings whose unfailing enthusiasm and receptiveness have made this collaboration such a pleasure for all concerned.

HELEN SMAILES AND MUNGO CAMPBELL
National Gallery of Scotland

General Reading

BILLCLIFFE Roger, *The Glasgow Boys: The Glasgow School of Painting 1875–1895* (London 1985)

The Scottish Colourists (London 1989)

CAMPBELL Mungo, *The Line of Tradition: Watercolours, Drawings and Prints by Scottish Artists 1700–1990* (National Galleries of Scotland 1993)

ERRINGTON Lindsay, THOMSON Duncan, and ELLIOTT Patrick, *Scotland's Pictures: The National Collection of Scottish Art* (National Galleries of Scotland 1990)

HALSBY Julian, *Scottish Watercolours 1740–1940* (London 1986)

HARDIE William, *Scottish Painting 1837–1939* (London 1976)

HARTLEY Keith et al, *Scottish Art Since 1900* (National Galleries of Scotland 1989)

IRWIN, David and Francina, *Scottish Painters at Home and Abroad 1700–1900* (London 1975)

MACMILLAN Duncan, *Scottish Art 1460–1990* (Edinburgh 1990)